SPICE GIRLS
and the clothes they wear

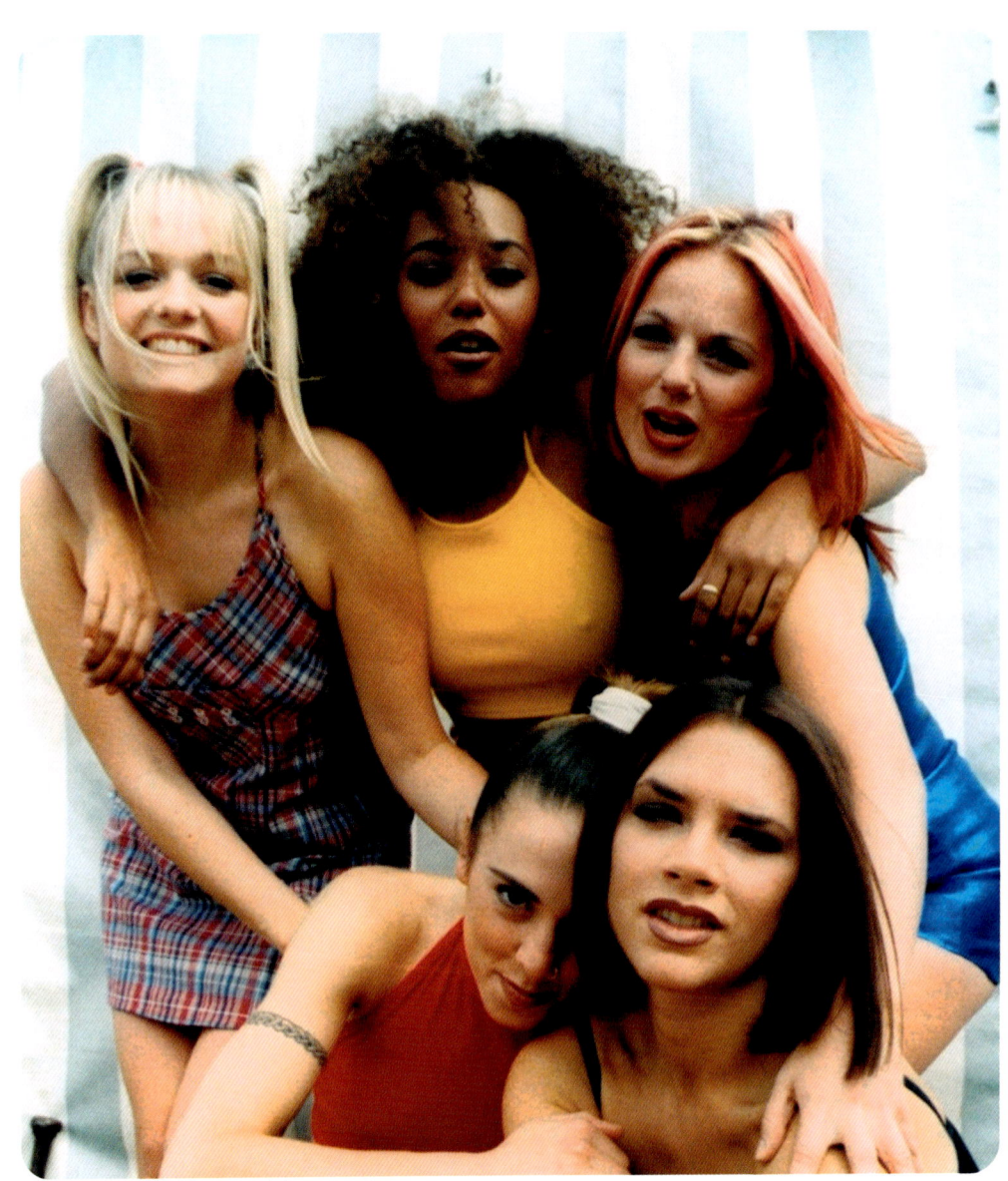

SPICE GIRLS
and the clothes they wear

Terry Newman

ACC ART BOOKS

Introduction

> 'They are THE ultimate babes. Love them... I feel like every girl was inspired by the Spice Girls'.
> **Charli XCX, *On Air with Ryan Seacrest*, 2014.**
>
> 'It's incredible looking back on it now. We were bold, brave and fearless. It's a huge legacy!'
> **Emma Bunton, *HELLO!*, October 2023.**

The 1990s were a moment in time that would live forever, not least because of the success of the Spice Girls who embodied breaking down barriers and unapologetically celebrating yourself for who you were, regardless of race, gender, or class. It was a decade when the outsider became the insider and in 2023, guesting at The Business of Fashion 'Voices' conference, Victoria Beckham told the audience that starting out in 1994, she and the rest of the Spices had felt like the 'underdogs'. They wanted to be on the cover of magazines, but were batted back and told that girl bands don't sell. However, by November 1996 they had appeared on the front of the most blokey and credible of music newspapers, *NME* and in 1998, Anna Wintour featured them for the undisputed holy grail of fashion, American *Vogue's* lead story. The '90s were an era when creative energy in the UK was motivated by a search for identity, individualism, and a personally defined style, all fuelled by a defiant kick against what had come before. New, different, odd and interesting were in and the cycle of high fashion had never spun so fervently. Fledgling, not long out of college, British design talent overhauled dusty, traditional Parisian fashion houses and became celebrities – John Galliano joined Givenchy in 1995 and Dior in 1996, Alexander McQueen was enlisted at Givenchy in 1996 and Stella McCartney by Chloë in 1997. In parallel, YBAs such as Damien Hirst and Tracey Emin reinvented art, and the Royal Academy platformed their work in a groundbreaking 1997 show, Sensation. Meanwhile, the concept of 'Cool Britannia' recharged the music industry, and Britpop bands including Blur, Oasis and Pulp stormed the charts. Geri, Victoria, Melanie C, Melanie B and Emma overtook them all, and riding the crest of this wave, conquered not just the UK with their irresistible energy, drive, and catchy tunes, but also the world. According to *bestsellingalbums.org* the Spice Girls have sold over 39 million albums, including 11,790,000 in

'I look back and smile about the Spice Girls now – I'm so proud of everything we achieved. It was about making people embrace who they are, being happy with who they are, being the best version of themselves and for that to be celebrated. And the fact that it was OK to be a little bit different – why conform, you know?'

Victoria Beckham, *Harper's Bazaar*, January 2020.

the United States and 5,400,000 in the United Kingdom. Their bestselling debut album, *Spice*, sold over 23,000,000 copies.

In May 1996, the girls were featured in *Music Week*; it was their first ever interview and the headline ran: 'Spice Girls: Taking on the Britpop Boys'. Its writer, Paul Gorman understood where they were coming from and reflected: 'Just when boys with guitars threaten to rule pop life... an all-girl, in-yer-face pop group have arrived with enough sass to burst that rockist bubble.' It had taken them two years to break through. As legend has it, Northerners, Melanie C and Melanie B, who grew up on council estates, and Victoria Adams, raised in the leafy commuter belt village of Goff's Oak in Hertfordshire, all replied to an advert placed in show-business newspaper, *The Stage*. Father-and-son team, Bob and Chris Herbert who ran Heart Management were looking for 'streetwise, outgoing, ambitious & dedicated' singers and dancers to create a group. Watford-born Geri, charmed her way into the second round of auditions, and won Heart over by singing: 'I Wanna Be A Nightclub Queen'. After more try-outs, Geri, Victoria, Mel C – who was reconsidered after her mum had called up explaining she'd only missed the second round of auditions because of tonsilitis – and Mel B were put together with original member, Michelle Stephenson, in a house in Maidenhead, Berkshire, initially christened Touch and started rehearsals. Stephenson was fired relatively quickly and replaced by North Londoner, Emma, the daughter of a milkman. The fab five gelled, hatched a plan and soon left Heart Management. As Victoria once put it, they escaped with the master recordings 'hidden in Geri's knickers'. Looking back, Chris Herbert said afterwards: 'Their belief in themselves was their superpower.' They took up with a new manager, Simon Fuller, who eventually signed them as the Spice Girls to Virgin Records in July 1995 – who were chosen, as Geri pointed out, because the label 'offered us a chance to go our own way.' Girl Power the Spice way meant winning writing credits, self-determination, and an identity of your own: it was a potent and convincing message that inspired legions of young women to grow up believing they too could be as strong and successful as Posh, Ginger, Sporty, Baby and Scary.

Right from the start, the girls demonstrated clear-cut characteristic styles. As biographer Sean Smith relates, according to Chris Herbert, Mel B had a 'young, funky look' even at those early auditions. Victoria 'stood out, dressed all in black with a crop-top showing off a tanned midriff', and Mel C had a 'boyish image' donning tracksuit bottoms and a crop top. When the girls first met Geri, she turned up in 'a tight pink jumper, purple hot-pants and platform shoes', Mel B observing: 'She looked like a mad eccentric nutter from another planet.' Emma was the youngest member of the group, and partial to a Tweety Pie T-shirt and pigtails naturally became 'Baby'. In a 1997 *Girl Talk* interview

the girls reflect on and break down their looks. Posh 'likes smart clothes and high heels', Ginger opts for 'vintage originals', Baby shops at 'Camden and Miss Selfridge', while Sporty 'hates shopping' and 'gets everything from JD Sports.' Scary, true to form, has a 'leopard skin lamp, a leopard skin chair, leopard skin pillow, leopard skin underwear and nightie,' admitting 'I love it! As soon as you walk into my bedroom you feel like you're in the jungle. And I crawl around and purr!' In a March 2020 *Guardian* interview, Mel C describes how casually their show identities were established saying: 'Historically, lots of girl bands have dressed the same or been very coordinated. When the Spice Girls started, we tried a few different looks, but it just wasn't working for us. One day, we were looking at ourselves in rehearsal and I was in a trackie, Geri was in some crazy outfit from a secondhand shop, and we thought: why don't we all just wear what we're comfortable in? We realised that our individuality was a great selling point – lots of fans felt that they identified with at least one of us.' The Spice Girls' closet became a blueprint for devotees who warmed to the clothes they wore, which in turn became fashionable and ultimately went on to reflect the zeitgeist of the '90s in a fashion language that was accessible. Their image was ingenuously authentic. In a 2023 *nylon.com* interview the wardrobe designer for *Spice World the Movie* revealed that she dressed the girls as they always had been which meant: 'tons of Buffalo trainers… we had a whole separate truck just

> ' I look back at my fashion and I go, "Nailed it!" '
>
> **Melanie Brown, 'Dopamine Dressers' on *YouTube*, 2022.**

> ' Being a Spice Girl is the best thing ever... Once a Spice Girl, always a Spice Girl. '
> Melanie Chisholm, CBC, November 2022.

for their shoes and boots', while 'Bunton wore Topshop and designers like Blumarine', and 'sports brands like Adidas were shipping boxes of merchandise for Mel C to wear. Meanwhile, Geri's outfits were mixed with many vintage pieces.' The girls used clothes as a medium and message to define who they were and in doing so validated others' choices to be themselves too and whether you were boyish, had a 'fro, wore heels or trainers, liked thrifting or designer clothes, the band helped widen the possibilities of what it meant to be a stylish woman. You didn't have to stay in a box, and this was the unfaltering objective of girl power. In a 2021 *Marie Claire* article, Geri explained: 'How you saw us in public was very much our own individual style: Mel B was street and funky; Emma was sweet and baby doll; Victoria was minimalist but designer-driven (I remember Victoria coming into the studio one day wearing Manolo Blahnik shoes, and I was mesmerized); Melanie C rocked the sneakers and tracksuits...' And as for herself, she says: 'I was a mix of everything vintage, sassy, and expressive (depending on what day it was!)'. The girls and their clothes didn't offer a solution

to everything, but did give visibility to women's strengths and helped consolidate emerging forms of third-wave feminism with a blast of freshness and a commitment to inclusivity.

The sensation of the Spice Girls had global resonance, and this attracted attentive brands and product marketeers to align themselves with their energy and pulling power. Although fan sites and chat rooms existed online, and Virgin Records' official SG website was pulling in 1.3 million visitors per month in 1997, social media had not been invented and the monetarisation of success was yet to become a career choice. However, the band became prototype influencers and embarked on a rollercoaster ride of endorsements and collaborations that hardly stopped for breath. They became a trademark and were ambassadors for Generation Next, in all its complicated consumer-loving glory. In 1997 the girls signed up to be the face of Pepsi, which meant 92 million cans of pop featuring the band were distributed around the world, and exclusive track, 'Step to Me' was released on a CD that could

Prince Charles (now King Charles III) joins the Spice Girls at a gala evening, 11 May 1997.

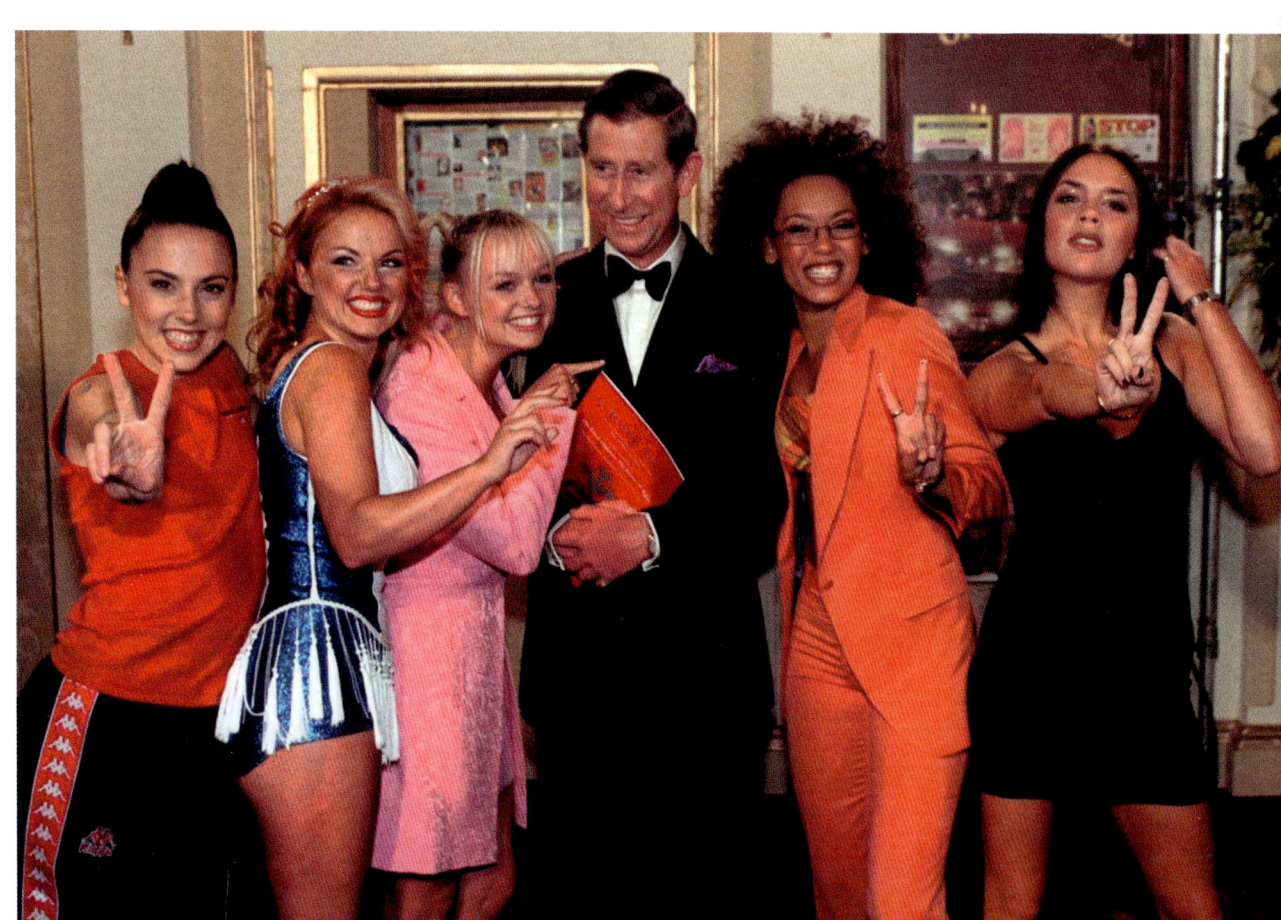

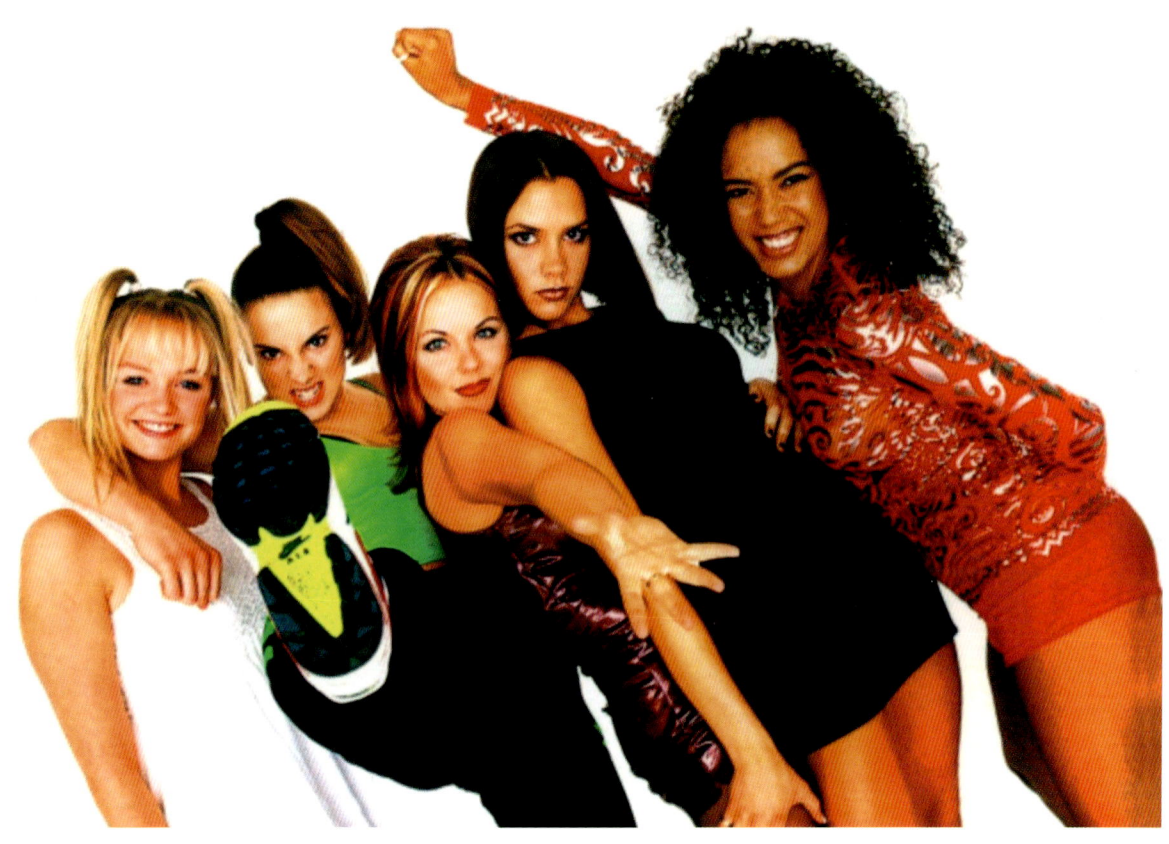

only be obtained by saving ring pulls. *Campaign* magazine reported that the soft-drinks company subsequently 'increased its share of the European cola market by 1.6%', while 'Rising Tower' Buffalo boots in the Pepsi red, white and blue colourway which accessorised the launch became must-have collectibles. A year later the girls became 3D characters in a Sony PlayStation interactive game, *SpiceWorld*, where players created their own virtual concerts and although in retrospect the blocky graphics and tech are elementary, the collaboration anticipated how years later the music industry would consider immersive, digital metaverse experiences a key promotional objective. Alliances were formed with profile-raising crisp companies, lollipop, tattoo and body-spray manufacturers; pizzas, duvets,

The Spice Girls in 1996.

backpacks, friendship rings and collect-them-all baseball cards were made in their names and, of course, dolls, and this was just the tip of the girls' promotional iceberg. Ray Cooper, the managing director of Virgin at the time, explained in a 1997 *Forbes* article the potential force behind the marketing's 360-degree success, saying they seem to be: 'the first group ever that have got 4-, 5- and 6-year-old girls and boys to buy music.' While criticised by some at the time, many compare the Spices' comprehensive foray into myriad forms of marketing to the way The Beatles manifested their own back in the 1960s, and today this systematic business practice is commonplace.

The Spice Girls personified the '90s when the atomisation of fashion meant that everything and everyone could be in style. Their approach to life laid the foundation for the new millennium both culturally and sartorially – they were a group of five individuals who had clear and authentic qualities and styles to match. Niche rather than uniform ideas proliferate today, because being different means creating an inclusive environment for all, where equality and diversity are represented. Many who grew up with the girls have continued to be motivated by their message. After the Spice Girls split up for good in February 2001, each member continued to create music. Melanie C has sold over 20 million records and Geri a respectable 15 million while Emma, Mel B and Victoria have all also released bestselling albums. Victoria is a key player in the fashion industry and in a 2018 ENews red-carpet report at the People's Choice Awards in LA, after being awarded their inaugural 'Fashion Icon' prize, she reflected on her time as a designer, saying: '... it started as girl power. And now it's about empowering women through fashion.' Mel B is a transatlantic television personality starring on hit shows and Emma a radio star and businesswoman. Geri meanwhile has become an author. However, their appeal today has become even bigger than the music. They are totemic household names and their legacy lives on – inevitable for a band who have toured the world with blockbuster shows, are on giggling terms with British royalty and caused legendary anti-apartheid activist and politician Nelson Mandela to blush in November 1997 and admit they were his 'heroines,' going on to say that he was feeling emotional and that it was 'one of the greatest days' of his life. The greatest and the good are happy to go public about their reverence for the Spice Girls. Adele posted on her Instagram after watching them perform at their Spice World 2019 Wembley gig where Geri, the two Mels and Emma reunited, admitting: 'It's no secret how much I love them, how much they inspired me to run for my life and never look back...I couldn't have got here without you 5 BRITISH legends! I love you!' Kim Kardashian, Beyoncé and Billie Eilish are equally superfans and actress Emma Stone confessed in 2018 on *The Tonight Show Starring Jimmy Fallon* that although her real name was Emily, she went

up to her teacher on the first day of second grade and asked to be called Emma as she wanted so much to be Baby Spice. Spice love runs wide and deep; respected thespian Brian Cox admitted he was a closet Spice Girls fan and sang their hit, 'Wannabe' on an episode of *Carpool Karaoke* along with Alan Cumming who starred in *Spice World the Movie*. In a 2021 *Guardian* interview, Cumming revealed it was not just his favourite film but a 'golden' time in his career; he loved the girls, saying: 'They were young, humble, irreverent, and talented, and on the ascension. That moment I spent with them working on the film was their time, their innocence, when everything they did was charming and powerful at once.' Similarly, the world has watched these 'underdogs' thrive and flourish, and prove that wherever you come from, whoever you are, it is indeed possible to spice up your life in whichever way you dream.

' The Spice Girls doesn't belong to the five of us – the band is everyone's... Whether you were five, 15 or 25, through us people saw that they could be themselves. Yes, the music became a soundtrack to a time. But it went beyond – it was a movement. '

Geri Halliwell, the *Guardian*, September 2023.

Brit Chick

· · · · · · · · · · · · · · · · · · · ·

> ❛ When that tea towel was stitched to that little black Gucci dress, I had no idea of the reaction that was going to come. ❜
> — Geri Halliwell, *Vogue* interview, YouTube, March 2020.

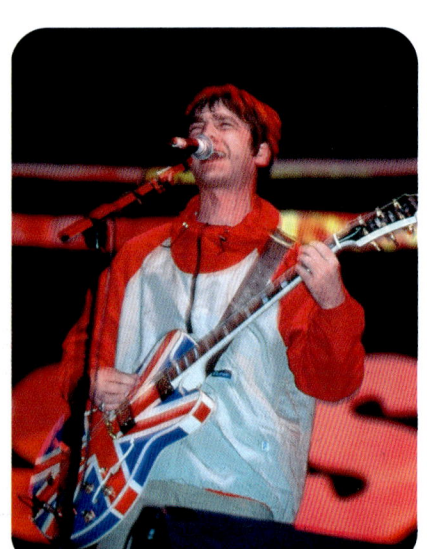

Back in the 1960s, the Union Jack enjoyed a fizzy heyday, when British culture experienced a global high and the famous national symbol stood for all things post–war and fresh. Twiggy, one of the first modern supermodels, who epitomised the spirit of youthful styling, became the bastion of swinging London. Her string-bean figure was shot by the best photographers in the world, including Terence Donovan, who famously placed her in front of the British flag in '66, while Pete Townsend of mod band The Who often appeared onstage sporting a Union Jack jacket. 30 years on, Brit Pop reincarnated many traits of the swinging sixties and enjoyed equal success around the world, flying the British flag, which bounced back from its deconstruction and desecration by the punk provocateurs of the '70s.

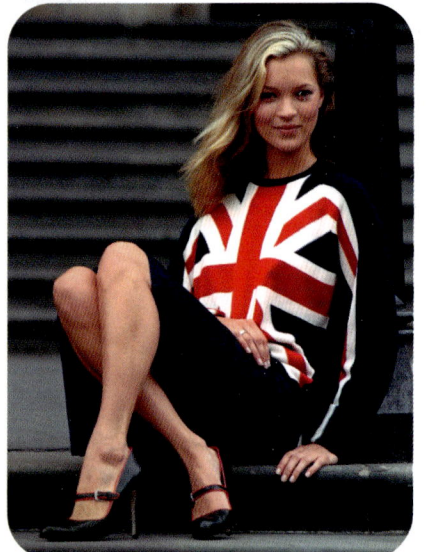

THIS PAGE TOP: *Liam Gallagher of Oasis with his Union Jack guitar at the Manchester City Stadium in April 1997.*
THIS PAGE BOTTOM: *Supermodel Kate Moss poses for the media on the steps of the Natural History Museum in London for the start of London Fashion Week, September 1997.*
OPPOSITE: *Geri Halliwell wearing THAT Union Jack dress onstage at the 1997 Brit Awards.*

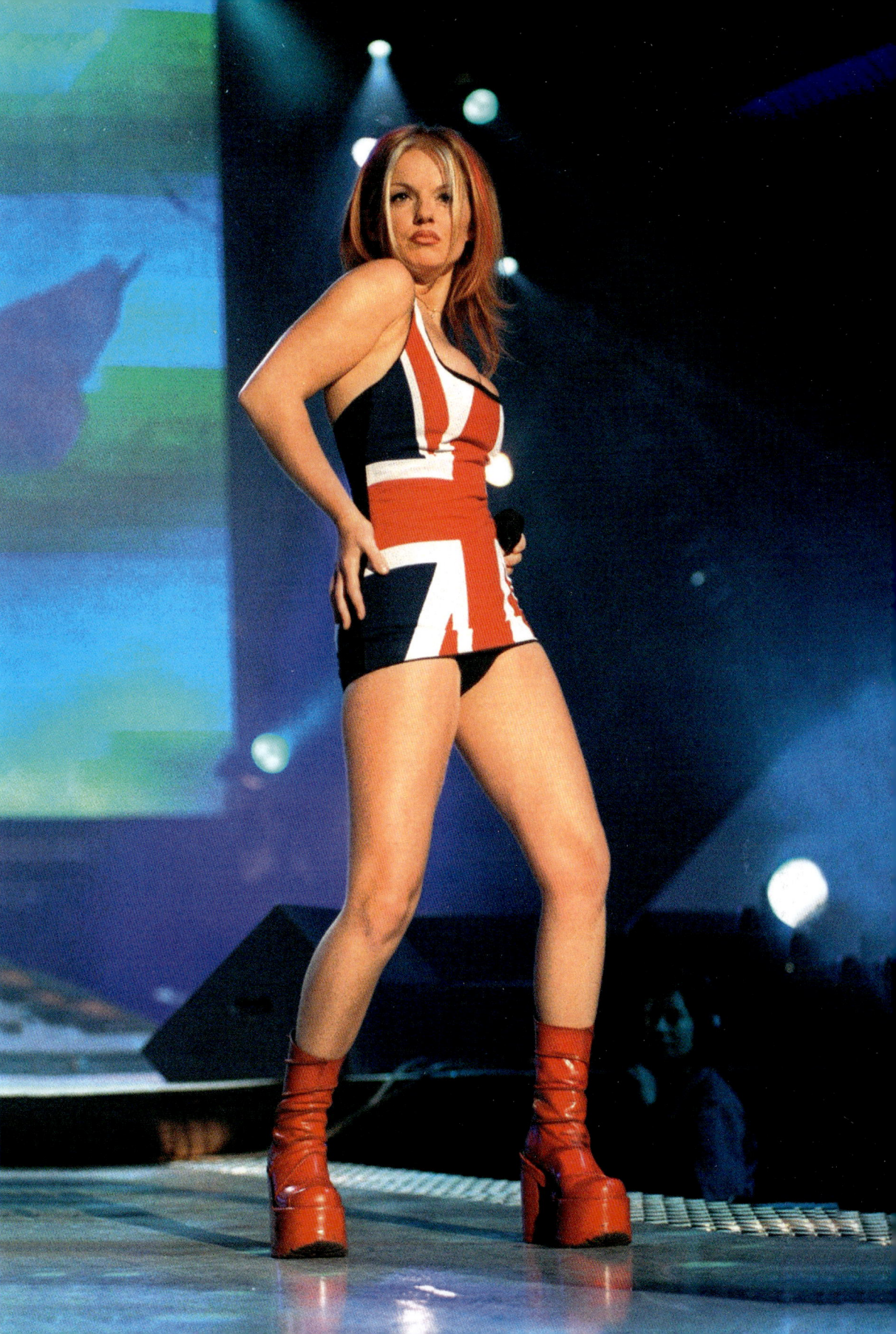

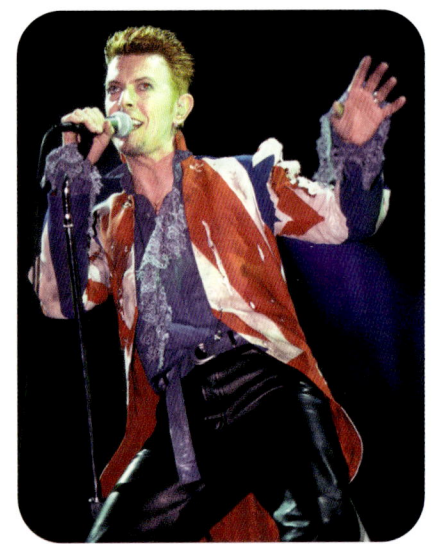

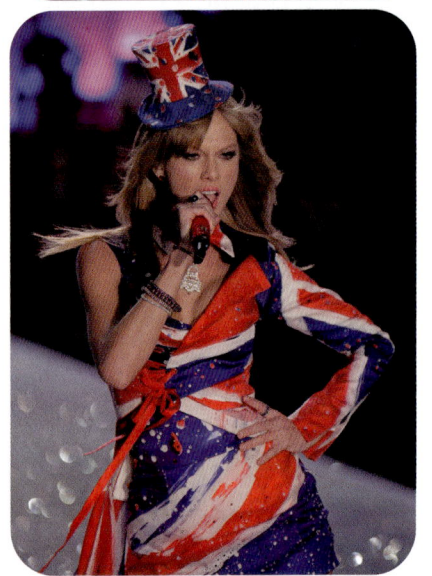

In 1996, David Bowie wore a Townsend-inspired tailcoat, designed by Alexander McQueen, during his *Earthling* tour. And Liam Gallagher strummed a Union Jack guitar when Oasis were at the peak of their powers. A year after the release of Spice Girls' debut LP, *Spice*, the ultimate Union Jack fashion moment came together at the February '97 Brit Awards, when Geri Halliwell wore a Union Jack dress for their performance. It was a Tom Ford for Gucci ultra-mini dress to which Geri's sister had stitched a cut-up Union Jack tea-towel. She later told *Vogue*, 'I've always tried to put my finger to the wind and feel what's going on right now. And if I feel it, maybe you'll feel it too, and we'll connect'. The March 1997 *Vanity Fair* cover featured Liam Gallagher and his wife Patsy Kensit snuggling under a Union Jack duvet, with the strapline: 'London Swings Again'. In the September, Kate Moss launched London Fashion Week wearing a Union Jack sweater. Geri's intuition, it seemed, was bang-on. In 1998, the original frock was sold at Sotheby's to the LA Hard Rock Hotel for over £40,000, which Halliwell donated to Sargent Cancer Care for Children.

THIS PAGE TOP: *David Bowie, 1996.*
THIS PAGE BOTTOM: *Taylor Swift at a Victoria's Secret show in 2013.*
OPPOSITE: *Spiced up – Ginger performs at the Olympic Stadium on 12 August 2012.*

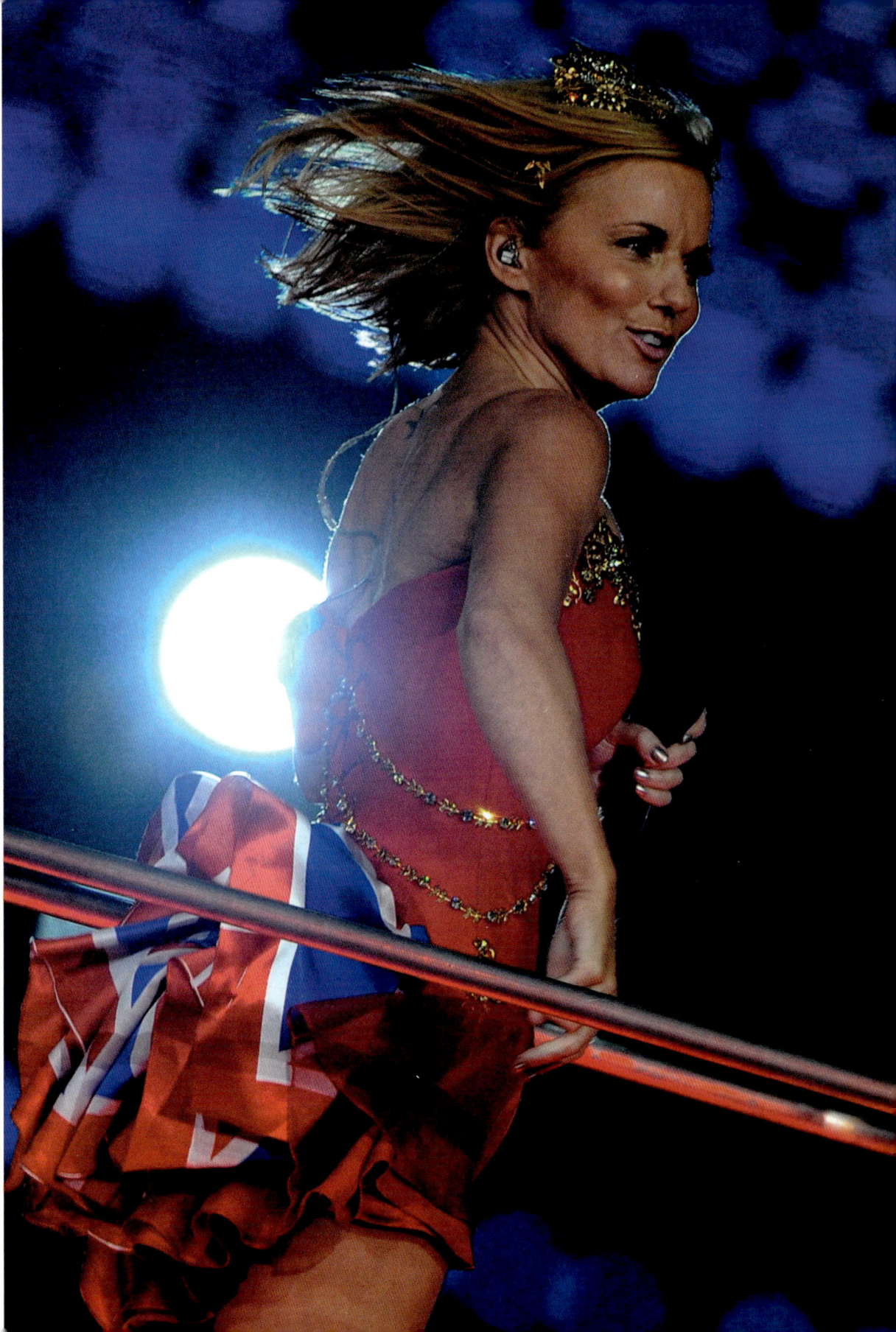

Hear Me Roar

> *'... to wear leopard you must have a kind of femininity which is a little bit sophisticated.'*
> — Christian Dior, *The Little Dictionary of Fashion*, 1954.

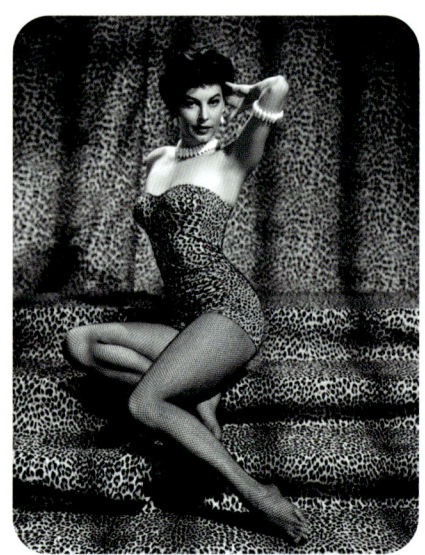

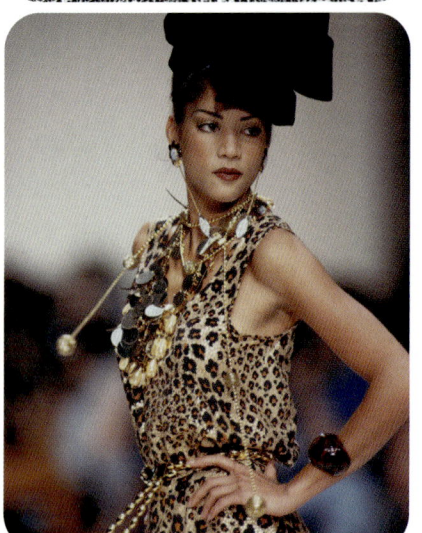

If fashion is a language, wearing animal print speaks of boldness, of sharp claws and barely contained dynamism. Mel B turned the motif into her own special message during the '90s when, in various guises, it helped to signify her inner power. Today, it's synonymous with Scary Spice and she has revisited the look on numerous occasions since leaving the band. Judging the finale of the 2023 drag singing competition, *Queen of the Universe*, she wore a slinky leopard catsuit created by Bang London, whose stage apparel is famous for rising to the challenges of the most self-assured customers.

Leopard has a bombshell quality when it comes to everyday wear, largely thanks to 1950s Hollywood starlets, like Lana Turner and Ava Gardner, who made it widely accessible. However, its chic history goes further back. In the 1920s, Nancy Cunard, the heiress and activist who was muse to the likes of Samuel Beckett and Aldous Huxley, wore it with pride and always looked divine.

THIS PAGE TOP: *Ava Gardner in 1952.*
THIS PAGE BOTTOM: *Veronica Webb modelling for YSL in 1992.*
OPPOSITE: *Scary Spice at the Billboard Music Awards in 1997.*

In the 1960s, it was chosen by political royalty, such as Jackie Kennedy, and actual royalty, like Queen Elizabeth II. But the potent print has also appeared in the wardrobes of punk princess Blondie and grunge icon Kurt Cobain. American designer Norman Norell and Frenchman Christian Dior had both showed how elegant its charm could be in the 1940s, before Yves Saint Laurent's work in the '80s gave it a wildly left-bank allure. It was this fierce, off-the-wall, yet somehow charming mantle that Mel B then picked up and ran with in the '90s.

Roaring success – Mel B performs with the other Spice Girls at the Brit Awards in 1997.

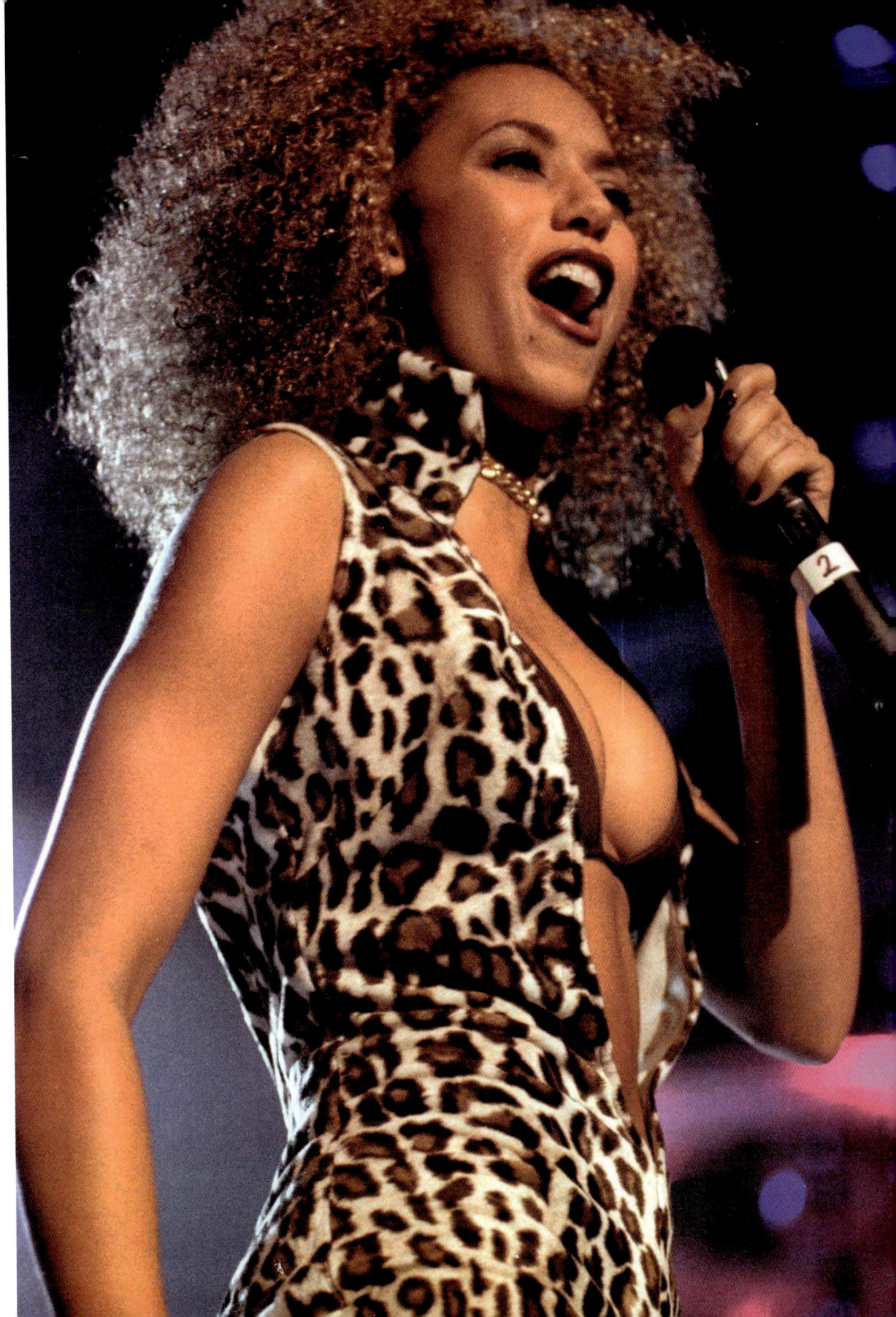

The KISS Principle

'It must be really hard for you, Victoria. I mean, trying to decide whether to wear the little Gucci dress, the little Gucci dress... or the little Gucci dress.'
— Mel C, *Spice World: The Movie*, 1997.

One of the lingering after-effects of Seattle grunge and its thrifty pick-and-mix styling was a simple aesthetic, characterised by starkness. Helmut Lang, whose first collection debuted in 1986, helped set the tone for this '90s dress-down trend. The photographer, Elfie Semotan, a close friend and collaborator of the Austrian designer, explained Lang's rationale: 'He taught men how to look cool and elegant without looking like they had thought too much about their clothes. He stripped back then re-formed ideas from the past without having to always invent everything from scratch.'

Posh Spice's definitive silhouette was the little black dress – sophisticated and unfussy, with clean classy lines. One of VB's favourite designers during the Spice Girls' heyday was Tom Ford who, as creative director of Gucci, fathomed a new approach for the esteemed House, developing it into a brand known for its sexy take on minimalism. Ford gets a name check in *Spice World*, and when the band went to

THIS PAGE: *A classic Tom Ford for Gucci outfit at the AIDS Project benefit gala in Santa Monica, 1997.*
OPPOSITE: *If you Cannes dance – Posh Spice at the 50th Cannes Film Festival, 1997.*

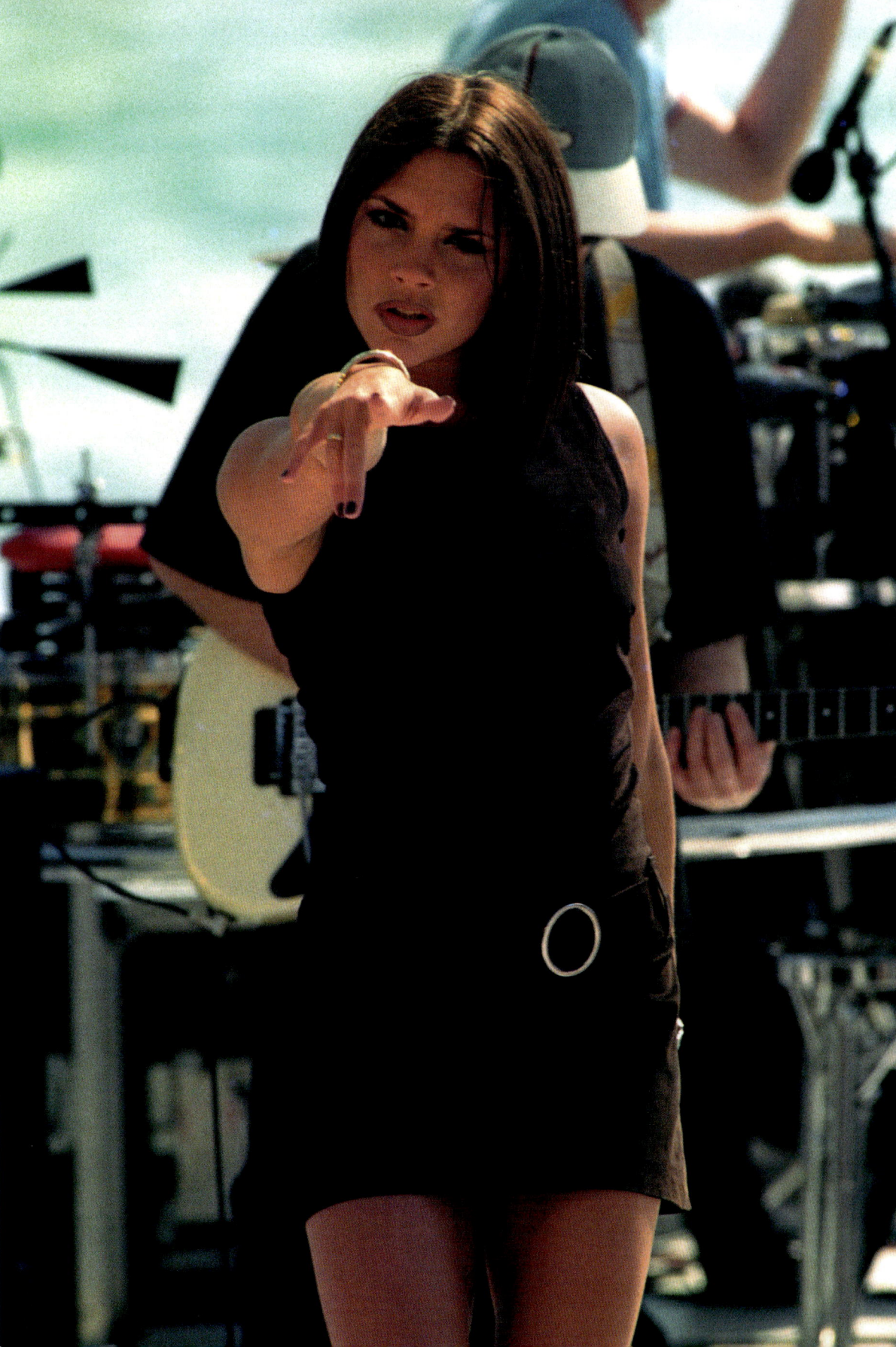

Cannes to announce their new project, Victoria's key outfit was an ultra-sassy sleeveless black dress, adorned only with a low-slung belt – very much in keeping with Gucci's new, pared-back, hipster detailing. Today, Victoria is a fittingly posh designer with her own eponymous brand known for its effortless poise and regular reworkings of the little black dress of her youth. Ease is still at the heart of her creative DNA. As she explained in a 2020 interview with *Harper's Bazaar*: 'It's about presenting clothes that are elevated enough for the catwalk but that people are actually going to wear; it's never about showing fashion for the sake of showing fashion. I don't want to wear things that are complicated.' And her latest collections still subliminally channel the '90s minimalism of her formative years in the spotlight.

Poshed up – Victoria onstage at the Amigo Awards in 1997.

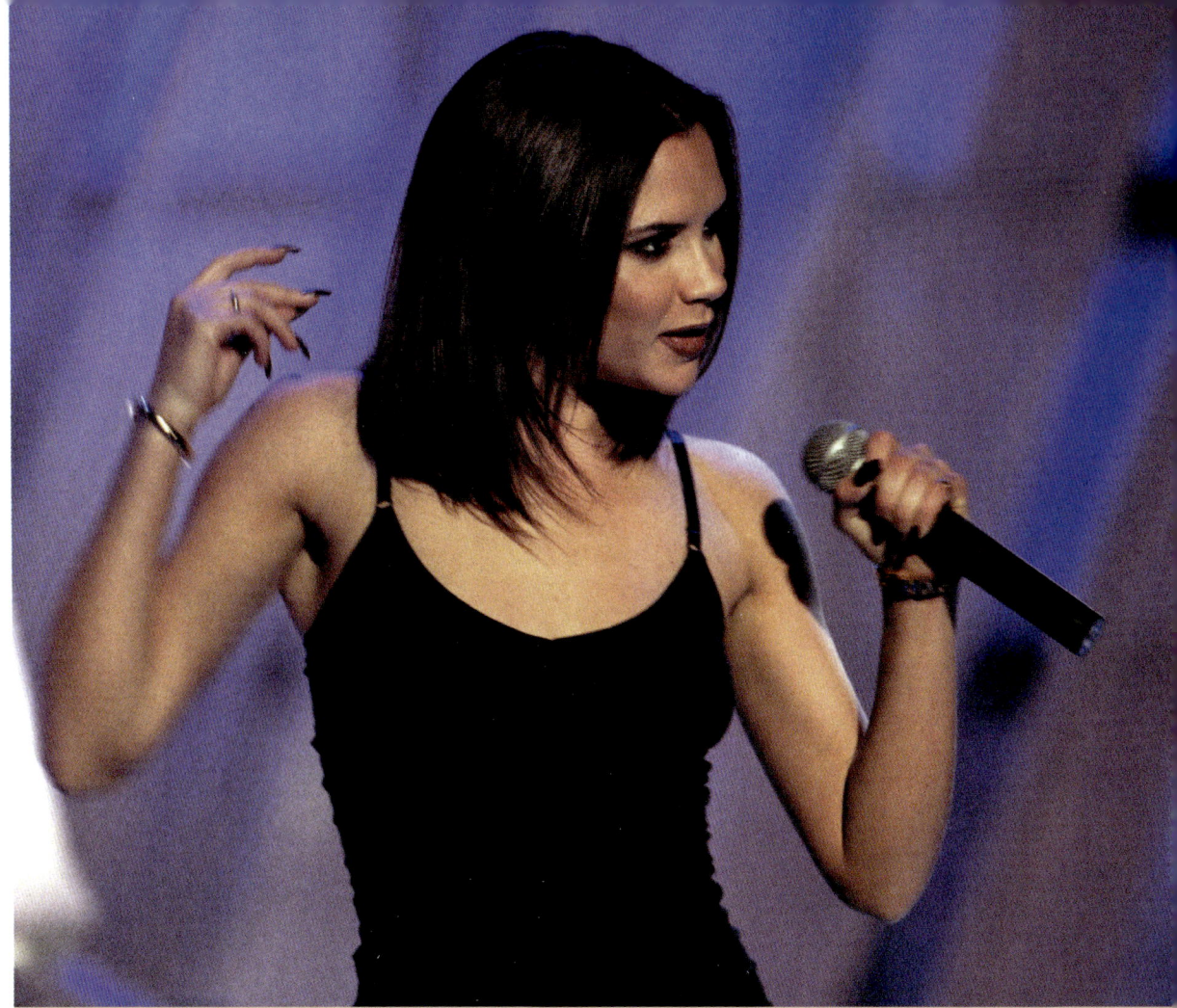

' ... the other Spice Girls **weren't really into fashion,** so I was fortunate to be able to **take up most of the budget.** '
— Victoria Beckham, *Vogue*, July 2022.

On Brand

' **I can't just wear it when I want to** because I feel like I look like an impersonator of myself. '
— Mel C, *The Sydney Morning Herald*, December 2016.

In 1993, Ralph Lauren opened the Polo Sport Emporium on Madison Avenue. But it wasn't until 1997, when Prada Sport was launched, that athleisure became a definable trend. Through this diffusion line, Prada brought a pragmatism to luxury wear that was spot-on for the time. Velcro fastenings, toggle drawstrings, mobile-phone pockets, hoods, and zip-out puffa layers met the needs of an ultra-fast urban lifestyle, and Prada Sport also exploited the latest high-tech fabrics, initially developed for extreme weather sports (like sailing and mountaineering) for their comfort and quick-drying, breathable qualities. In parallel, the athletic look became a lifestyle choice. American brands Calvin Klein, Donna Karan, Ralph Lauren and Michael Kors helped instigate a sportswear craze that swept the globe, while Galliano debuted fencing waistcoats, and Karl Lagerfeld sent sequinned surf suits up the international catwalks. Sportswear has always fitted comfortably with subcultural styling though. Not long after Adidas launched the iconic three-stripes tracksuit in 1967, the German brand began to enjoy the upsides of

Sporty Spice in full Adidas getup, Lulworth, UK, July 2023.

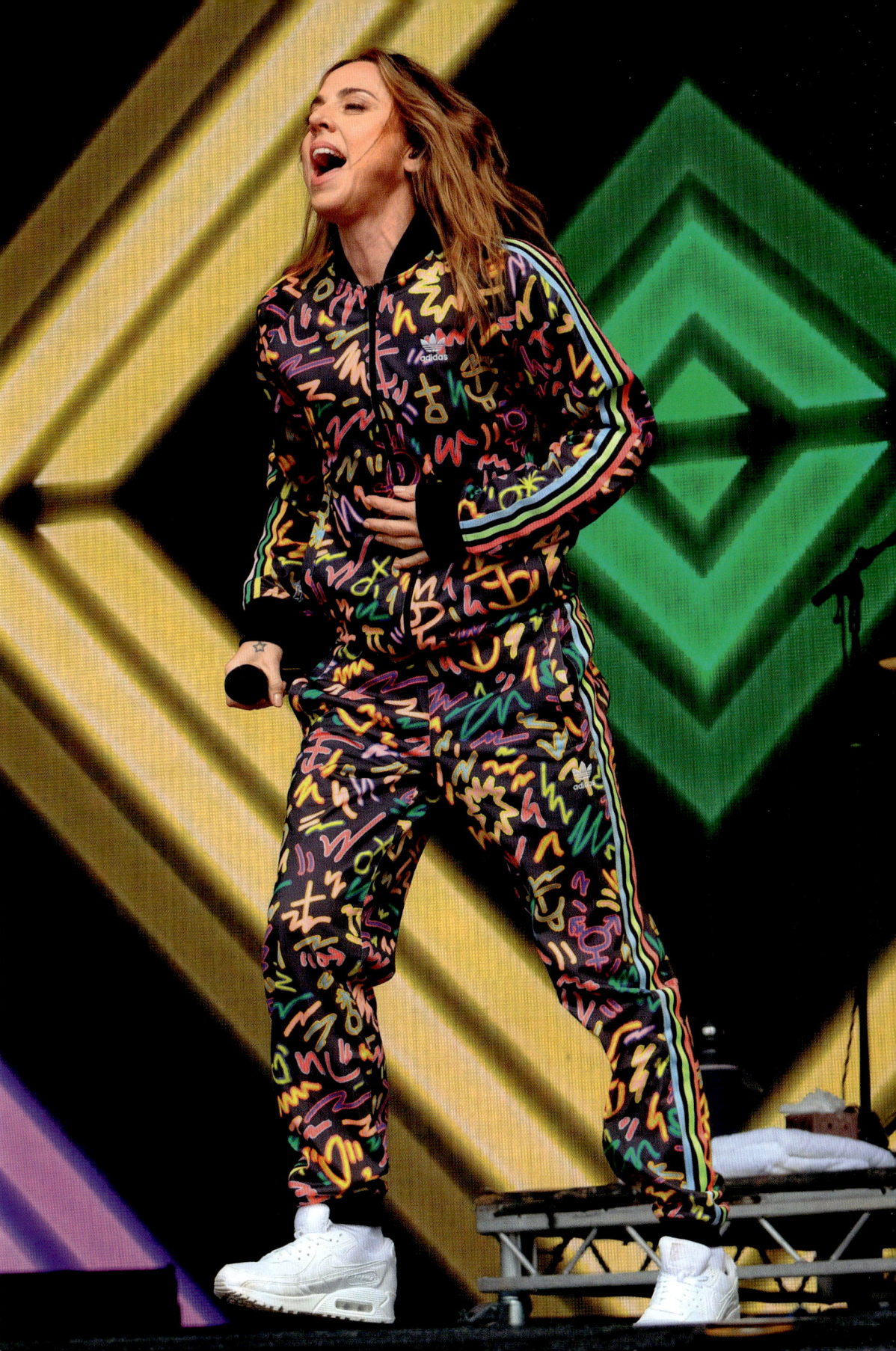

underground approval. UK casuals in the '80s sought out expensive, Italian 'old man' labels like Lacoste, Ellesse and Fila in dusty golf shops, which made these leisure labels covetable too. However, as street dancing and hip hop grew into a truly global cultural phenomenon, Adidas staked the most convincing claim to cool. While young soul and electro kids were wearing European sportif as fashion, over in NYC, the likes of Run DMC were sporting the three stripes and trefoil motif as well. Into this up-to-the-minute arena strode Sporty Spice, who personified the street value of activewear. Even if the other spices appeared far more fashion conscious, the reality is that Mel C caught the crest of a very trendy wave, and her trackies eventually achieved legendary status.

Three lines on the shirt – Mel C (right) rocking her classic Adidas tracksuit jacket, sometime in the '90s.

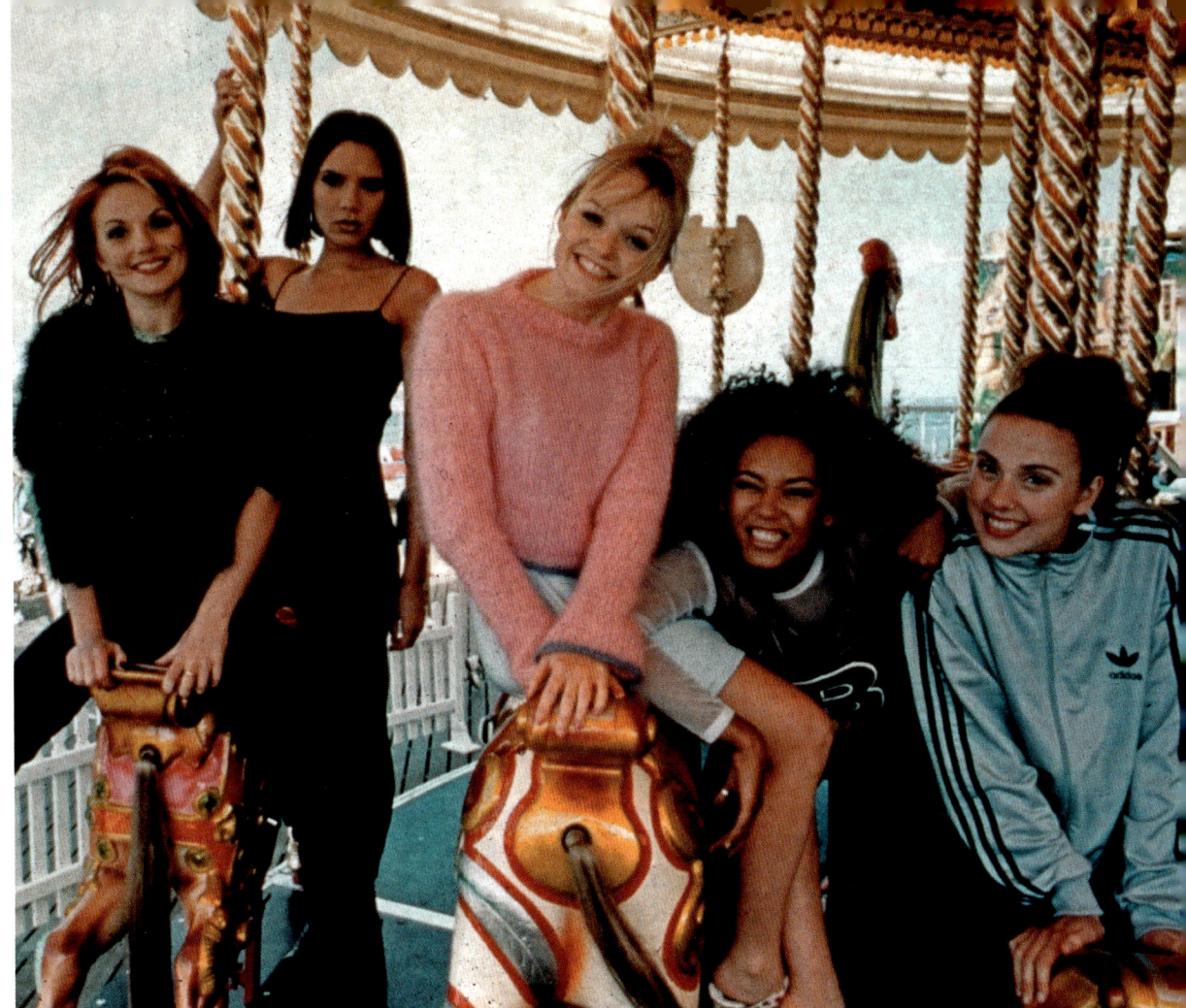

" I would love to see King Charles in a trackie.
I think he'd wear it well. "
— Mel C, *Sunday Times Style*, 2022.

Think Pink

· ·

'I don't think I will ever get tired of wearing pink.'
— Emma Bunton

The Italian surrealist designer Elsa Schiaparelli created her very own shade of pink in 1937. Christened 'shocking pink', she used the tone to add a jolt of passion to everyday proceedings. Similarly inclined fashion luminaries adored its high-voltage essence, including *Harper's Bazaar* and *Vogue* editor Diana Vreeland, who delighted in pairing it with other reddish shades and once exclaimed aloud, 'I *adore* that pink!' Yves Saint Laurent powered up pinks in the '80s, famously combining it with clashing reds and creating sultry collections for wearing under the electric stars of Studio 54. He regularly used baby pink in his designs and at times his work would challenge its honeyed history. For example, his 1980 'Shakespeare' collection featured a quilted rose jacket embroidered with a poem by Dadaist intellectual Jean Cocteau, knowingly evoking the arty attitude of Schiaparelli.

THIS PAGE TOP: *Emma in pink, June 2021.*
THIS PAGE BOTTOM: *The Molly Goddard Ready to Wear A/W show in February 2019.*
OPPOSITE: *Baby performs during the 20th Brit Awards, 3 March 2000.*

Emma Bunton's sweetie approach to styling was always underlined with a pop-art edge. When Baby Spice wore pink, it was always with a sprinkle of sass and the spirit of girl-power. Designers today, including Molly Goddard and the relaunched House of Schiaparelli, know how to play with the tone, as the semiotics have shifted since the turn of the millennium and the colour has a spectrum of connotations. Baby's take remains relevant and, in a Barbie World, credible: sugar and spice, but without being too nicey nice.

' Pink makes women, whatever age, look fresh and therefore younger. '
— Yves Saint Laurent, *House Beautiful*, 1977.

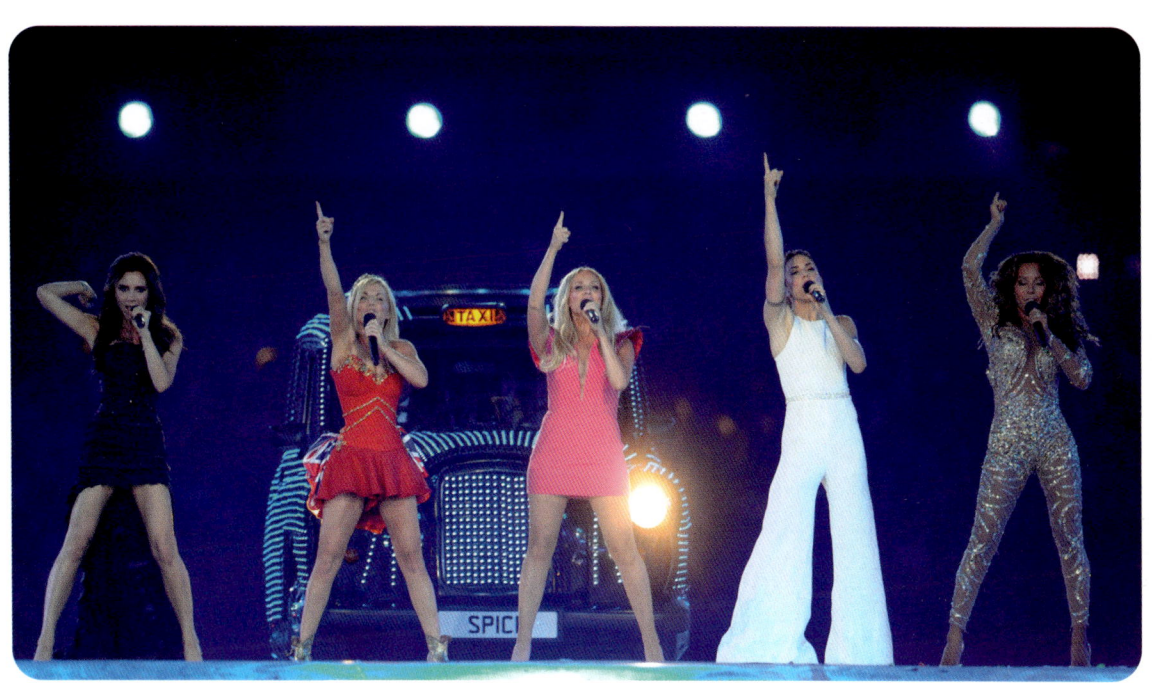

THIS PAGE: *Baby Spice (centre) performs at the 2012 Olympics.*
OPPOSITE: *Fashion Eeveelution – Schiaparelli A/W show in July 2018.*

Tight Fit

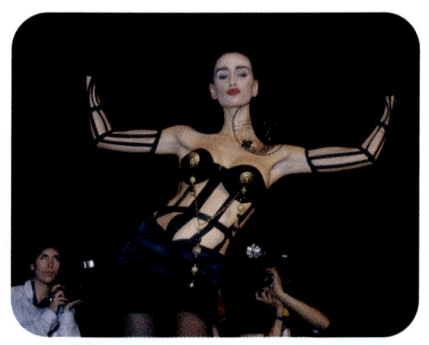

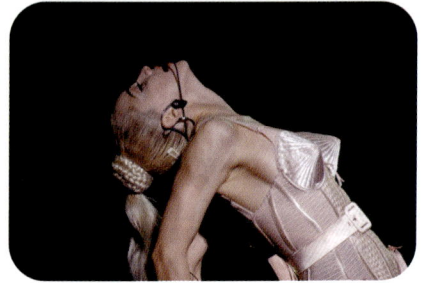

The Spice Girls' rallying cry of 'Girl Power' was a clarion call for women to be what they wanted to be; not what society dictated. And if they wanted to wear gorgeous underwear in public then that was fine – better than fine. It was a message to the world that they were daring to challenge feminine norms. Although the 1990s are relatively recent history, people would still casually criticize a woman if she had the 'audacity' to show off a little cleavage. Founded in 1994, the lingerie company Agent Provocateur hit the headlines with its vivacious and impertinent underwear. In doing so, they helped create a cultural space where wearing sexy smalls was acceptable, and women could begin to feel confident owning and even enjoying their sexuality. Then, when Geri Halliwell wore a corset in public, it demonstrated very publicly the kind of freedom that might be taken for granted nowadays. This is very much down to thoughtful and

THIS PAGE TOP: *Gaultier's S/S show in Paris, 1989.*
THIS PAGE BOTTOM: *Causing a Commotion – Madonna in Tokyo, 1990.*
OPPOSITE: *Ginger Spice in February 1997.*

inventive designers, such as Jean Paul Gaultier and Vivienne Westwood, who took the historic piece in the '80s, making it a signature and essentially rebranding it as an edgy and cutting-edge style option.

THIS PAGE: *Sequins of events – Geri (left) onstage with the other Spices at the 1997 EMAs.*
OPPOSITE: *Hallelujah – Geri takes shelter from the rain during the Spice Girls' peak.*

' Feminism has become a dirty word.
Girl power is just a nineties way of saying it.
We can give feminism a kick up the arse.
Women can be so powerful when
they show solidarity. '
— Geri Halliwell, *The Official Spice Girls' Girl Power*, 1997.

Suits You

> '*My costumes were out of this world, and once I had my catsuit on, my weave as big and bouncy as I could possibly make it, and my high heels, I felt invincible.*'
> — Mel B, *Heat*, December 2019.

As Scary Spice, Mel B very quickly adopted all-in-ones as a signature look. The strong, unashamed fashion statement suited her down to the ground. It gives no opportunity for dithering with nuanced separates, trying to match patterns and shades. It's forthright and final. In the '90s, catsuits were seen on the runways of some highly persuasive designers. Azzedine Alaïa's A/W 1991 collection is seen as a vintage example of the Tunisian's talent for turning kitsch into chic. His trademark body-con-friendly fabric, made of spandex and wool, was turned into a series of feline forms, helping to set the catsuit trend for the decade ahead. In 2019, Kim Kardashian posted a series of images online of her wearing an especially covetable piece, captioned: 'you don't understand, this is an Alaïa' – a line from the classic 1995 film *Clueless*. Thierry Mugler also stood proud as a catsuit innovator. His first examples were shown in 1974 in his pioneering Galactic Sirens collection. And Diana Ross modelled a crystal embellished

THIS PAGE TOP: *Print on demand – Kim Kardashian wearing Alaïa in 2019.*

THIS PAGE BOTTOM: *All-female factory workers in Baltimore during WWI.*

OPPOSITE: *Flower power – Mel B at the London Mardi Gras in 2001.*

mesh version on the runway in Mugler's S/S 1991 show. In a 2021 *iD* interview, Casey Cadwallader, speaking as Mugler's chief designer, explained the silhouettes' appeal: 'The catsuit allows comfort in a very daring capacity. There's a certain level of confidence and fearlessness needed to wear it because you are showing your shape completely. But at the same time, it makes you feel reassured because everything's contained, nothing's going to rip or jiggle.'

Another classic all-in-one is the jumpsuit. An altogether tamer fashion beast, jumpsuits have their origins in the workwear worn during WWI by women in factories. They have since been reformed into popular and elegant day-to-evening outfits by the likes of American designer Geoffrey Beene, who in the 1980s enthusiastically called it 'the ballgown of the next century'. Mel B embraced the modern jumpsuit for red-carpet calls, as a sophisticated substitute for her usual skin-tight prowler. Today, catsuits can be found selling online as Scary Spice Halloween costumes. Indeed, Mel herself dressed up as Scary Spice in the iconic leopard-print suit for a celebrity Halloween party – very Scary!

One cool cat – Mel B attends the Pride of Manchester Awards in 2022.

Smarty Pants

Snug and sexy Fiorucci trousers predate by a couple of decades the Y2K indie-sleaze skinny jeans of the Spice Girls' peak era. Worn by disco-era divas such as Donna Summer and Diana Ross to parties at Studio 54 during the 1970s and '80s, and by indie darlings like Kills lead-singer Alison Mosshart in the '90s, these hip huggers have crossed many a divide. When a young Victoria Beckham started slipping into their slinky silhouettes, her personal field of reference may well have included the 1978 movie *Grease*. The film's prim heroine, Sandy, transforms into a souped-up bombshell at the prom fair, wowing the crowd in a pair of black 'pants' so slim that she was famously sewn into them.

THIS PAGE: *Olivia Newton-John dances with John Travolta in the 1978 Paramount production of* Grease.
OPPOSITE: *Victoria performing in 1998.*

Such tight fits can subtly reveal whatever figure you have and, in a post–MeToo world, a woman's shape ought not to be a matter of public debate. As a connoisseur of cool, Posh Spice continues to champion the formfitting line in her keenly received VB fashion House collections. But back in the day, the Spice Girls were constantly challenged to defend their fashion choices and – insidiously – their weight. One incident that never fails to make jaws drop is the infamous TV moment when Victoria, looking fabulous in her signature narrow black trousers, made a guest appearance on a '90s entertainment show. A mere two months after giving birth to her first boy, Brooklyn, Victoria was questioned as to whether she'd lost her baby–weight. Not only that, but she was actually asked to prove herself live on air. In a 2022 *Vogue Australia* interview, Beckham described being made to 'stand on the scales to be weighed. Can you imagine doing that nowadays?'

Spiced rum – Vicky B goes for red legs at the Saint Laurent A/W 2022/23 show in Paris, March 2022.

We Won't Back Down

> **'** Because I had this tomboy image and I loved my football, **people thought I was a bit mouthy,** a bit loud, part of that ladette culture. **'**
> — Mel C, *BBC News*, August 2020.

It was almost impossible to win if you were a woman before the turn of the Millennium. If you dressed for sex-appeal, you were either catcalled or reprimanded and if you dressed down, you were labelled a ladette and told off for being too bolshy. In this binary environment, erring on the supposedly tomboyish side of the line earned Mel C a special set of complexities. For some reason, the world's press couldn't let it lie that Mel C liked wearing androgynous sports clothes. Nevertheless, she continued to wear footie tops to high-profile events. In turn, music was helping to shift football culture away from the aggy-macho vibes of the decades prior. This new trend was arguably kicked off by the song 'World in Motion' by New Order and the England national team ahead of the 1990 World Cup. The Brit-Pop wave swept up fans during Euro '96 with the 'Three Lions' theme-tune by Baddiel, Skinner and The Lightening Seeds, which echoed around lager, lager, lager-ed up clubs and pubs. In the '80s, the beautiful game had produced its own subculture of working-class style-busters called Casuals, who wore

Mel C during the video shoot for England's official 1998 World Cup Anthem, 'On top of the World'.

tennis labels like Sergio Tacchini and Lacoste with Forest Hill trainers to matches. They were equalled at the time by the Paninaro in Milan, who fashioned a similar aesthetic from Armani and Timberland. Ironically, this brought an element of dress-up to the terraces, before the opposite happened in the post-rave era, when the footie shirt was adopted by general trendsetters. Today, Mel C's love of bloke-core feels as fresh and free as ever, while many top-of-the-league designers from Burberry to Louis Vuitton have been equally inspired by the numbered polyester tops.

Sporty Spice herself is no stranger to a football song, having guest-starred on a few, including 2023's 'Call Me A Lioness' anthem released ahead of the Women's World Cup, saying at the time: 'It's been amazing to see the popularity of women's football grow and their incredible win last year was a huge inspiration for this new song for the world cup. I'm so privileged to be involved with a whole host of amazing female artists, cheering on our women's team to bring it home again!'

Squad goals – four of the Spices line up for a photo in Miami, 1996.

' In this country's backward cultural way, it's: "Oh, she likes football, she must be gay." Well, some are, some aren't. But the ones that are, are out. The men's game – different, I know; it's such a masculine, macho environment, steeped in tradition – could learn so much from the female game. '

— Mel C, *attitude* magazine, October 2022.

A Child of the Sixties

' I love that era, from way back, I love that whole '60s mini-skirt/big boot [look]. **It's just something I feel comfortable with.** *'*
— Emma Bunton, *IGN.com*, February 2005.

Emma Bunton's Baby Spice wardrobe leaned very naturally towards the dolly shapes of the 1960s. The enduring appeal of '60s fashion can be viewed as a comment on the strength of the '60s feminist movements, which were something of a touchstone for equal rights. The youth-quake of the swinging '60s also encouraged a gear shift in the industry – being young and having fun with fashion was where it was at. Mary Quant's designs were right at the heart of a new silhouette for women. Sold at her boutique, Bazaar, which opened on King's Road in 1955, the hemlines were high and the dresses were worn with tights, rather than stockings, meaning skirts could be as daringly short as the wearer wanted. Clothes bought from Carnaby Street boutiques, like Lady Jane, were decorated with space-age sequins, psychedelic swirling patterns and lots of colour blocks. No longer would trends be dictated by Parisian fashion Houses. Instead, new styles

THIS PAGE: *Suzy Kendall in a Biba dress, 1966.*
OPPOSITE: *Groovy baby – Emma Bunton onstage at the Party in the Park, 2001.*

emerged from the streets, often as part of a wider cultural revolution. In turn, the dynamic drive of young people began to influence high-fashion creators, such as Yves Saint Laurent who opened his first ready-to-wear store in 1966.

Baby Spice's retro version of the '60s in the '90s meant buying second-hand, which became a very contemporary statement, while pop-tastic girls hunted for go-go boots and lively A-line frocks in hip markets like Portobello Road and Camden. Fashion's trend cycle has since been obfuscated by the cult of the individual, but that means that there is rarely a moment when wearing 1960s vintage doesn't look right. Designers still reference its *joie de vivre*, and a multitude of modern catwalks, including Moschino, Miu Miu, and Marc Jacobs, habitually pay homage to the moment in time when looking good was all about expressions of joy.

THIS PAGE: *Moschino runway, Milan, 2012.*
OPPOSITE: *Emma Bunton in* Spice World the Movie.

Declare Your Hair

Mel B didn't think twice about wearing her hair in a natural afro during the 1990s. And many saw her as an unpretentious role-model. In fact, she was enthusiastically unapologetic about her 'fro. It completed her look and symbolised the Spice Girls mantra, which was all about being an unadulterated version of who you are. Her curly-textured tresses served as a super-high-profile alternative to the box-braids, wigs and permed hair styles that were fashionable while she was in the band. In the early 2000s, the natural hair movement of the '60s was revived online, with word spreading about how to style Black locks without using products to 'relax' the bounce. It's taken a while for inclusivity in fashion to catch up with Mel B, but designers today increasingly embrace the afro, with catwalk shows from the chicest Parisian Houses readily featuring them. At Dior's Cruise 2020 collection, Maria Grazia Chiuri chose the natural hair look for her Black models, who wore designs by North African artisans. And established names, like Imaan Hammam, regularly rock red carpets and catwalks with the full Mel B look, all helping to inspire a new generation of Scary Spices.

THIS PAGE TOP: *Ethel Coley and Joanne White, members of the original 1968 London cast of* Hair.
THIS PAGE BOTTOM: *Imaan Hammam at the Met Gala, 2023.*
OPPOSITE: *Keen spectator – Mel B wins the Female Spectacle Wearer of the Year award at the Fashion Cafe in London, 25 March 1997.*

‘ My hair was my identity
and yes it was different to all the other girls...
but that was what the Spice Girls were about –
celebrating our differences. ’
— Mel B, the *Independent*, 2020.

Freaky Streaky

As a symbol of defiance, coloured hair first made its mark on the heads of provocative punks in the 1970s. Their spiked Mohawks, like many of the clothes they wore, were DIY-dyed at home by any means necessary. Unnatural and alien, it's a fashion message signalling that stylistically you are not on the same page as everyone else. By the early 1990s, stripy hair was *de rigeur* for techno-cybergoths, who used it to cutely coordinate the highlighter hued garms made by the likes of Camden Market legends Cyberdog – set up in 1994 to sell industrial-strength and cartoonishly futuristic clubwear. The resulting look was akin to the kind of Japanese streetwear inspired by anime and manga, with larger-than-life locks tinted to emulate classic characters like Shura Kirigakure and Nia Teppelin.

THIS PAGE: *Gigi Hadid for Versace in 2017.*
OPPOSITE: *Streaks ahead – Mel C at the Billboard Music Awards in Vegas, December 1998.*

Sporty and Ginger Spice made bright contrasting colour-blocking a characteristic of their own when the band hit the big time in 1996. The look was becoming of their vibrant personalities, and a light-hearted expression of their girl-power philosophy. In the early 2000s, sulky Emo kids insolently turned up the volume of their jet-black bangs and asymmetrical fringes by adding primary-coloured chevrons, blazing a trail for the likes of Paramore's singer, Hayley Williams. Her red-and-orange-banded hair and, of course, Billie Eilish's signature slime-green-striped mop of wonderfulness have kept the vibes alive. Meanwhile, disparate designers from Versace, for A/W 2017, and Rick Owens, for A/W 2020, have honed their own catwalk versions. It's always satisfying to see every now and again when a little alt-girl attitude is required.

THIS PAGE: *Sporty at the Forum Assago in Milan, March 1998.*
OPPOSITE: *Reddy or not – Ginger Spice owns her look in October 1996.*

Top Bob

*' I had very, very straight hair.
[I was] addicted to the hair straighteners.
Super, super, shiny straight hair! '*
— Victoria Beckham, *Vogue.com*, 2019.

Back in the '90s, Posh Spice's sleek-and-chic bob became a cultural phenomenon with a fanbase all of its own. However, this simple haircut has historical roots. It was a game-changer for women who wore it to assert equal cultural status with men, especially upon its emergence in the West, post–World War I, due to the necessary role reversals that had taken place in the workplace. Women had moved to factories and fields and taken over traditionally male jobs, because men had been drafted to the frontline to fight, but economies needed to keep moving. Such radical changes shifted women's place in society. Androgyny became fashionable and the frills and furbelows of corseted dressing, popular pre-conflict, were abandoned for boyish, string-bean silhouettes. The gamine charm of a bob helped to energise and embolden the bright young things who daringly and symbolically had their hair cut short.

THIS PAGE: *Twiglet – Teenage model Twiggy with her fresh haircut in 1966.*
OPPOSITE: *Victoria in Paris, September 1996.*

The sixties in many ways echoed the androgynous vibes of the '20s. Supermodel Twiggy's 1966 haircut by Leonard of Mayfair catapulted her to global stardom, and celebrity hairdressers were feted like rockstars. Vidal Sassoon, for example, was almost as famous as The Rolling Stones and his geometric bob, worn by Mary Quant, was an electrifying success.

Victoria's keen adoption of the bob reflected her status as the ultra-fashion Spice. It was christened the POB (posh bob). Over the years, Beckham's bob has manifested in blunt, blonde, choppy, flicky and bleached varieties, proving just how versatile the cut can be.

THIS PAGE: *Vidal Sassoon sculpting Mary Quant's signature bob, 1964.*
OPPOSITE: *Posh arrives at the annual Elton John Party at the Pacific Design Centre in LA, 2007.*

Girly-Locks

Fashion was fragmented during the 1990s. In many ways, the decade heralded the disintegration of the kind of mono trends that dictated what was in or out. There was no one way of being cool. The post-modernism subversion of archetypes made it perfectly possible to wear old styles in new ways – for example, sporting multi-coloured hair in adorable bunches without feeling submissive or stupid. Japanese Harajuku girls in the 1980s and '90s, as photographed by Shoichi Aoki and featured in the cult Japanese streetstyle magazine *FRUiTS*, showed the world how creative and pop-fabulous street styles could be. A shopping district in Tokyo, kids often congregate in Harajuku on Sundays to show off exactly how little they care about mainstream fashion. Pigtails were a favourite in '80s Harajuku and a signature of the ever-proliferating, Victorian-doll-inspired Lolita subculture that appeared on Harajuku's concrete catwalks before blazing

THIS PAGE TOP: *Mel Morinaga at a Street Style session during Design Festa Vol. 43 in Tokyo Big Sight, 2016.*
THIS PAGE BOTTOM: *Quinn some pigtails – Margot Robbie as Harley Quinn in* Suicide Squad, *2016.*
OPPOSITE: *Baby in Glasgow, 1998.*

a beeline into the Western consciousness with the arrival of social media. In time, the various Harajuku stylings would inspire fashion Houses like Jeremy Scott and Marc Jacobs, who became fascinated by their alternative individuality. Meanwhile, in the state of Washington, in the early '90s, punk-feminists of the Riot Grrrl scene reclaimed lady-like fashion tropes, pulling them apart and re-joining the dots until a blurry haze emerged, which meant that cute wasn't just okay, it was political. By the time Baby Spice hit the charts in 1996, her pigtails perfectly emblemised a new wave of being unapologetically pretty in a super-sweet way. The semantic trajectory of pigtails has continued apace, notably with the appearance of Margot Robbie's Harley Quinn in the 2016 DC superhero movie *Suicide Squad*, where her cutesy blonde tails proved exactly how far from saccharine swish the childhood bunches had come.

Emma Bunton in Spice World the Movie.

' I have always been proud of my pigtails. I've got very thin hair and it's all about volumising the hair for me. Sometimes I probably back-combed a bit too much but I think the bigger the better. '
— Emma Bunton, *mailonline.com*, 2015.

Double Bubble

The nostalgia for the post-rave '90s double-buns hairstyling has become a standard for retro aficionados. It's a look that has been re-platformed by celebrities and designers keen to glean some of its space-cadet-meets-club-night feels. It's also synonymous with the Spice Girls. When *Spice World* came out in 1997, Scary souped it up with a conical and beribboned medieval-maiden effect.

Since the Y2K era, buns have shaken off some of their fluoro-fuelled energy and found a new place in the hearts of style-seekers, but the Spice Girls link remains. In 2020, J.Lo's 250 million online followers were treated to pics of her as '#CinnamonSpice' with sleek and chic hair-buns. Janelle Monáe wore her own distinctive buns to Paris fashion week in March 2019, accessorised with pearls and paired with a Thom Browne preppy suit and socks. In 2018, New York label Opening Ceremony took the double-*chignon* to its childhood home when they celebrated Mickey Mouse's 90th anniversary with a Disney-inspired collection featuring 'Minnie Ear' hair.

THIS PAGE TOP: *A Young Hopi woman in Santa Fe, 2018.*
THIS PAGE BOTTOM: *Actress and singer Janelle Monác in Paris, March 2019.*
OPPOSITE: *Hair 'em scarem – a frame from* Spice World the Movie.

Glammy Camo

Attitude was a huge part of fashion in the 1990s and the focus was not just on the glamorous fashion world of the rich and the beautiful. Grunge in the late '80s and early '90s helped pave the way for a new style of non-conformity. Suddenly, the outsider was interesting. As trends fragmented, an anti-style movement ran counter to the images of prêt-à-porter, haute couture and the mainstream fashion magazines. Fashion was motivated by a search for identity, individualism, and a personally defined distinctiveness, which suited the Spice Girls down to the ground. Their styling choices were often informed by clubbing crazes and in the '90s, nothing said you were hip as much as a camouflage print. The humble design has since scaled the heights of couture as in 2001 when Dior, with John Galliano at the helm, showed fatigue-printed silk separates and dresses. But camo's fashion history is all about counterculture. During the late 1960s and early '70s, defiant hippies appropriated military wear to protest war and in the '80s, it became synonymous with hip-hop stars like Tupac and Public Enemy, who raided army surplus stores

THIS PAGE: *Gisele Bündchen for Dior in Paris, October 2000.*
OPPOSITE: *Army girl – Victoria's camo t-shirt in NYC, 2018.*

and made it a uniform. Fashionable functionality made the print a fitting alternative to Mel C's trackies and sportswear and it was popular with Mel B who also took the pattern and remixed it, wearing camo bikinis and miniskirts. All the girls were kitted out in camo during the 'Dance Camp' sketch in 1997's *Spice World the Movie* and Posh showed how smart it could look when paired with stilettoes. Later, when she became a fashion designer proper, she revisited the print, making it deluxe and showing it on the Victoria Beckham 2019 Resort catwalk.

THIS PAGE: *Halliwell and Bunton play soldiers in a scene from* Spice World the Movie.
OPPOSITE: *Sporty Spice performs during the Amigo award ceremony in Madrid, 1997.*

Work-it Wear

Baby Spice's wardrobe was often charmingly innocent. She regularly slipped into a pair of lo-fi denim dungarees with an all-in-one romper to suit her adolescent aesthetic. This particular shape was no under-the-radar option and its legacy is tied to subcultural cool, having been favoured for years by beatniks and rappers. The Gen-X slacker charm of a pair of old overalls encapsulated an uncomplicated 1990s approach to looking switched-on but laidback. Wearing clothes you had thrifted was a rejection of overt labelling and helped sow the seeds for one of the '90s overarching ideals: don't look as if you are trying too hard. It just wasn't cool anymore.

The rise of denim overalls tapped into the growth of vintage as a persuasive fashion option. Discovering a pair of deadstock Lee or Levi's became the holy grail for second-hand dealers, who sold them on for fantastic sums to the

THIS PAGE TOP: *A* Soul Train *dancer at a photo shoot in LA, 1974.*
THIS PAGE BOTTOM: *Cathy Symmonds in dungarees, London, 1973.*
OPPOSITE: *Emma Bunton at Planet Hollywood in Las Vegas, 1997.*

growing community of collectors and designers who used classic silhouettes as templates for their own ranges. In 1977, Gloria Vanderbilt's high-waisted pants became an uptown phenomenon, but in the early '90s, designer denim was fixated upon by purists who harked back to its utility-workwear origins. Japanese brand Evisu launched in 1991, with its entire *raison d'etre* being to recreate the gold standard of hardwearing selvedge denim. Today, the charisma of overalls has transcended utility chic and can be found on the catwalks of myriad designers, from Jean-Paul Gaultier to grown-up goddess Isabel Marant, who have each remade the casual classic to meet their own high-fashion ambitions.

THIS PAGE: *A model wears Isabel Morant during her S/S 2020 show in Paris, September 2019.*
OPPOSITE: *Emma Bunton at Heathrow, 1997.*

Armless Fun

'**This dress is dry-clean-only,** Melanie!'
— Posh Spice, *Spice World*, 1997.

In June 1997, the *Times Magazine* fashion editor hailed the cool qualities of the strapless dress, saying: 'streetwise girls will be sunning their shoulders in slimming slinky jersey and longline silhouettes all summer long.' It's an uncomplicated shape, which has travelled far since it enjoyed a heyday in 1930s America, when couturier Main Rousseau Bocher introduced it to his socialite clients, such as the prominent heiress Daisy Fellowes. Christian Dior adopted it as a signature in the late 1940s and made it a defining silhouette that epitomised ultra-sophistication – wearers just needed elbow-length gloves and a swan neck to carry it off properly. By the 1980s, the lure of OTT puffball strapless Lacroix gowns made stars of those who wore them, but come spring 1990, Tunisian designer Azzedine Alaia had transformed it into a body-con, icily cool frock that resonated with a newfound authority. Designers began to experiment with fabrics and the August 1990 issue of *Vogue* described how Bill Blass sent a 'barrage' of them down the catwalk – in tweed, wool and camelhair – bringing the shape into the day-wear zone.

THIS PAGE: *Naomi Campbell dazzles on the runway for Alaïa, c. 1990.*
OPPOSITE: *Vicky bee – Posh Spice onstage in 1998.*

Posh embraced the strapless dress and attested her devotion at her London Fashion Week debut by modelling a maroon version from Maria Grachvogel's Autumn 2000 collection. She would later design her own examples after launching her fashion brand. However, although one of the key characteristics of the Spice Girls was their ability to define their own identities, when it came to the bandeau, they seemed to have similar feelings – even Mel C ventured to don a not–so sporty silver version to pick up the Best Dance Video trophy at the 1997 MTV awards.

THIS PAGE: *If you sleeve me now – Geri Halliwell at the Sony Radio Awards in London, 2011.*
OPPOSITE: *Baby and Sporty at the MTV European Music Awards, 1997.*

Born Slippy

The low-key slip dress was an in-vogue it-dress worn to fashionable '90s parties by the likes of Kate Moss and Naomi Campbell. The most disparate selection of designers – Prada, Comme des Garçons, Versace, Calvin Klein, and Michael Kors – all paid homage to the silhouette in their runway collections showing exactly how effective and adaptable the shape could be. And it seemed to fit with every iteration in the fast-spinning wheel of '90s style. It could be grungy, it could be minimalist, it could be vintage, it could be logoed-up and designer. It worked just as well for new-age crystal gazers as it did for skater-girls. It was a universal answer for any '90s woman with any kind of event to go to.

The key to differentiation was in the accessories and, of course, the hair. Emma Bunton and Victoria Beckham were fast friends of the slip-dress, travelling the world with a suitcase full, each adapting the frock to their personal style. Baby wore little pink versions with boots while Posh preferred black paired with stilettos, both preserving their individual identities despite rolling out in the same kit.

THIS PAGE TOP: *Donatella Versace (second from right) with a group of models in London, 1999.*
THIS PAGE BOTTOM: *Naomi Campbell and Kate Moss were among the models at the De Beers and Versace celebration, London, 1999.*
OPPOSITE: *Address the nation – Baby in Bali, 29 April 1997.*

Take Me as I Am

By the turn of the millennium, the Spices had become fixtures of the music biz – a notoriously patriarchal network. Some naysayers dared to call the Spice Girls' brand of women's lib into question. Baby Spice responded succinctly, saying: 'Girl power is about being whoever you want to be. Wearing your short skirts, your Wonderbra, and your makeup, but having something to say as well.' But the girls didn't just capsize stereotypical gender representation by asserting themselves, they also challenged expectations of class and race, becoming an inspiration for their fans, who would go on to believe they too could be who they really, really wanted. Mel B said in their 1997 VHS *One Hour of Girl Power* that the Spice mission was 'about spreading positivity, kicking it for the girls' – a manifesto that encouraged millennials to grow up with fresh expectations that they could speak their minds and that wearing a short skirt shouldn't make them a target for harassment. If the world hadn't worked out what the girls were about, then the dress Geri wore on *Saturday Night Live* in 1997 literally spelt it out. Their wardrobe, as ever, affirmed their values.

THIS PAGE: *Piece of history – Geri's Girl Power dress on display at Ripley's SpiceWorld Exhibition in London, 2015.*
OPPOSITE: *Geri brings the Spice Girls' special flavour of feminism to the SNL stage, 12 April 1997.*

Style guide – Geri performs for The Guide Association at Wembley Arena in 2001.

'I love the phrase "girl power"; it's stood the test of time and it's been around forever... Forget about labels, it's about embracing everyone's individuality...'

Geri Halliwell, *Harper's Bazaar*, June 2019.

Buffalo Sauce

Buffalo shoes were an unlikely breakout success in the context of '90s fashion. They didn't quite fit into the pioneering Antwerp Six school of deconstruction and they certainly weren't considered a designer classic. The most stylish magazines and editorials didn't include them in their circle of fashionable trust. However, even if *Vogue* ignored them, for many techno-club kids and cyber-goths, they were the footwear of choice. Geri, Baby and Scary enjoyed stomping around in Buffalo shoes while simultaneously looking showy, eye-catching and splendid. They didn't take them off for most of their peak era and the shoes even stayed on Ginger's feet when the group went to meet the now King Charles III at the 21st anniversary Princes' Trust concert in 1997 – an irreverent wardrobe pick, boldly co-ordinated with a sparkly blue bodysuit. That night, she also lent an orange pair to Mel B, who wore them with a matching tangerine suit. The same orange shoes would later be auctioned at Bonhams, fetching just under £1,000 for charity.

THIS PAGE: *Influencer Susie Lau, Paris, 2019.*
OPPOSITE: *Bullish mood – three of the Spices show off their Buffalo boots during their stay in Bali, 1997.*

> 'I am not taking responsibility for those big Spice Girls shoes!'
> **Victoria Beckham, *Vogue Visionaries*, 2022.**

Continuing the royal connection, Prince Harry admits in his memoir, *Spare*, that he was 'fixated' by Baby Spice's white 12-inch platform heels when he met the band in Johannesburg. Style gatekeepers have a notoriously flexible approach to what looks good when – today, a pair of 30cm Monster Buffalo boots, dating from 1996, are proudly placed in the Metropolitan Museum of Art's fashion collection. Designers as rarefied as Junya Watanabe have sent them strutting down the runway, and 2020s it-girl Gigi Hadid has been spotted sporting a baby-pink Opening Ceremony version.

THIS PAGE: *Geri in Bali, 1997.*
OPPOSITE: *The cheek of it – Geri Halliwell gets closer to Prince Charles (now King Charles III).*

Walk This Way

> ❛ Shoes must have very high heels and platforms to put **women's beauty on a pedestal.** ❜
> — Vivienne Westwood.

As the baby of the band, Emma Bunton admitted in a 2016 *Grazia* interview that 'it was quite difficult being away from home so much, but I had the girls – they were my rock.' Clothes also helped and, despite measuring up at only 1m 57cm tall, Baby towered above anyone who came her way – thanks to her celebrated sky-high heels.

In the 1970s, platform shoes were made covetable by Terry de Havilland, whose multi-coloured disco stacks were sold from his King's Road shop, Cobblers to the World – his celebrity clientele included Cher and David Bowie. You do need to be courageous to wear them though. In 1993 Naomi Campbell famously fell on the catwalk while modelling Vivienne Westwood's elevated Gillie heels. In 1997, when the girls were performing in Turkey, Emma similarly took a tumble onstage. Marc Jacob's Spring 2017 show featured an almost exact copy of Baby Spice's white platform dolly shoe. And Alexander McQueen's Armadillo shoe in his final show – the 2010 Plato's Atlantis collection – ultimately elevated the footwear to art status.

THIS PAGE: *Sole mates – supermodel Naomi Campbell in huge platforms, hugging legendary designer Vivienne Westwood, October 1993.*
OPPOSITE: *The wheel deal – Baby Spice lives up to her name for the World Cup anthem video in 1998.*

Bet Your Boots

Although her attitude was fierce, Geri Halliwell wasn't particularly punk. Instead, her assertive dress-up look was more akin to what glam-rockers, in all their shiny, glittery glory, might have worn in the earlier part of the 1970s. Ginger Spice's choice in footwear was fabulous and the giddy heights her boots reached in the late '90s were in tune with the mega-stompers worn by androgynous '70s icons like David Bowie, Marc Bolan and of course, the king of the astronomically high shoe, Elton John. Halliwell's most famous Union Jack sparkle booties, worn during the girls' 1997 Girl Power Live! In Istanbul concert, were designed by Shelly's, a popular shoe company that sold inexpensive but bang-on-trend styles and went on to become a Mecca for Spice Girls devotees during their hey-day. Super-fans were given a glimpse of these and more of the Spice shoe wardrobe when a touring memorabilia and clothing exhibition kicked off in 2008. Curated by Spice enthusiast Liz West, it coincided with the 20th anniversary of their debut track, 'Wannabe', when it came to the Watford Coliseum in 2017.

THIS PAGE: *Elton John in Virginia Water, 1973.*
OPPOSITE: *Platform for success – Ginger and Scary perform at the 1996 Smash Hits Poll Winners Party, where the Spices won three awards.*

Alongside the red, white and blue kicks were Geri's DIY sprayed white boots, a trick she came back to time and again when needing to co-ordinate an outfit – the cherry boots that accessorised her famous 1997 Brit Awards tea-towel dress had gotten the same treatment. However, Halliwell was a lover of all shoes, budget or not, and a pair of her very chic and pricy Prada Sport, knee high boots were auctioned at the victims of landmines charity, MAG, in 2008.

The Spice Girls onstage at the Smash Hits Poll Winners Party at the London Arena, November 1996.

'Music, along with fashion, is an expression: a way to explore my identity and communicate a sense of power. *Yes, I'm worth it. Yes, I want to be somebody.* '

Geri Halliwell, *Marie Claire,* **2021.**

Tattoo Crew

❛ **I love my tattoos and I like looking at tattoos in photographs,** but now when I think about getting older, you can look after yourself but you can't stop ageing completely. So there is going to be a point when I'm quite wrinkly and tattooed. ❜

— Mel C, the *Guardian*, May 2007.

There is an art vs fashion dichotomy when it comes to tattoos. While they are acknowledged as a creative practice, the imagery used for inking comes in trend cycles, much like hemlines. In the 1990s, tattoos felt especially fashionable, with designer Jean Paul Gaultier showing 'sleeves' on his S/S 1994 runway in Paris. They matched a certain sense of individual empowerment and expression, becoming a potent symbol of identity that by the turn of the millennium had slipped into the mainstream. Ink was no longer as rebellious as the tattoos worn by leather-clad bikers in the '50s and had evolved beyond the old association with sailors and their stick-and-poke versions.

For many women, getting a tattoo was about marking her body as her own. Mel C spoke about her ink journey in 2021, reminiscing about the now famous Tattoo Mania parlour in Los Angeles, saying: 'This little shop on Sunset Blvd, was always buzzing with different characters from The Strip. I think all five Spice Girls got some sort of tattoo in here, maybe with

THIS PAGE: *Jean-Paul Gaultier's Prêt-à-Porter collection in Paris, October 1993.*

OPPOSITE: *Ink-redible – Sporty Spice looks a million dollars with her skin art on show, c. 1997.*

the exception of Victoria.' Equally, tattoos of the Spice Girls themselves, are a major phenomenon, from Buffalo boots to 'Spice Up Your Life' to 'zig–a–zig, ah' – if you look, you will find all these and a lot more inked on devotees around the world. And for those a little less committed to the ink, Official Spice Girl merch in 1997 included removable tattoos in spiky rope and rose designs.

Victoria has had a number of tattoos successfully removed, including her husband's initials. This sparked a minor media inquisition. But Victoria dismissed the furore in typically straight–up Spice Girls fashion, saying: 'I'm just a bit sick of the tattoo. It's as simple as that.' Since then, David has added 'Posh' to his finger – the latest in a series of tatts dedicated to his wife – while their son, Cruz, also had 'Posh' tattooed on his elbow. Leave it to a Spice Girl to defeat the indelibility of ink – and in such carefree style.

THIS PAGE TOP: *Vanishing ink – Victoria's DB tattoo long before it was removed.*
THIS PAGE BOTTOM: *A good match – David Beckham's VB tattoo, England vs Brazil, Wembley Stadium, June 2007.*
OPPOSITE: *Mel B embraces an audience member during her* Brutally Honest & Fabulous Show *in Leeds, 2019.*

101

Name Game

In 1997, Emma Bunton's 'BABY' necklace sent fans into a frenzy of following suit, and paid homage to classic '80s rap move. The name necklace is a piece of jewellery with many origins, although in recent history, it was established most distinctly in 1980s and '90s NYC at stores like BBJ in downtown Brooklyn. Wearing a bespoke name necklace is about underlining your individuality, something style-setters in the '90s and 2000s relished. Today, it's a big mainstream trend that has exploded on the catwalks of Dior and Chanel. Indian jeweller Ashna Mehta's custom couture diamond Barbie necklace was modelled by Nicki Minaj, posted on *Insta* and worn to the 2023 film premiere. Queen B's 'DC', 'Yonce' and 'Mommy' chains have marked the evolution of her career from the early Destiny's Child days, while Rihanna's Fenty-tagged collar is another piece of savvy self-branding. In 2018, rapper Lil Baby reportedly spent $25k on 'gemz' for his son, with replicas of his own 'Baby' and 'Baby Jason' bling created by Atlanta-based jeweller, Icebox. But for Spice Girls fans, their best Baby will always be Bunton.

THIS PAGE TOP: *Lil Baby performing at the BET experience in LA, June 2019.*
THIS PAGE BOTTOM: *J Mulan in Houston, 2023.*
OPPOSITE: *Baby Spice in New York, 1997.*

Yes, We Cannes

Spice World is testament to the work ethic of the girls during their busiest years. It was filmed during a hectic schedule of travel, sparkling guest appearances and, of course, making music. Filming began in June 1997 and was completed by August, hitting cinemas by Christmas the same year. Prince (now King) Charles and his sons, Princes Harry and William, were guests of honour at the London Premiere and sat next to the band, who portrayed themselves in self-parodying style on the big screen. As Geri told the press at Cannes Film Fesitval: 'We're taking the mickey out of ourselves.'

The girls dressed up as icons like Marilyn Monroe, Diana Ross and Charlie's Angels, as well as swapping clothes and cosplaying as each other. In a 2023 *nylon.com* interview, costume designer Kate Carin revealed: 'I told the girls in my first meeting that I wanted the movie to look like a cartoon – Scooby-Doo on acid – and like a big, luscious bowl of the most exotic and colorful fruit. They loved that.'

Five Spices – the gang celebrate the release of Spice World the Movie.

> Women these days, they get it.
> Just be who you are
> and wear what you want.
> As long as it's authentic and true to you.

Mel B, the *Sunday Times*, October 2022.

Heralding the sartorial joy the film would bring, the girls arrived in Cannes to announce their film wearing 1950s-Grace Kelly-style headscarves, satirising the ultra-chic ladies who lunched in the South of France and setting the tone for their anarchic visit.

Ladies who launch – the Spice Girls take off in a boat during the Cannes film festival in May 1997.

'You know, sometimes a film festival can become a bit over-solemn. All this mooning about worshipping cinema is fine, but occasionally you do rather yearn for someone to creep up behind the whole earnest affair and cheerfully goose it. This year the Spice Girls volunteered for just such a role, bouncing into town to promote their forthcoming production... God knows what it's going to be like, but at least the mixed Spices did provide Cannes with a bit of a culture shock.'

Barry Norman, *BBC News*, May 1997.

Ladies First

> ' To win;
> it's just off its head... '
> — Mel C, MTV Awards, 1997.

After an excited group hug, The Spice Girls walked on stage holding hands to accept the Best Band honour at the November 1997 MTV Europe Music Awards show beating Oasis, U2, The Prodigy and Radiohead for the prize. Their energy was defiant and triumphant; Mel B shouted through the microphone, 'apart from this being the best day of our lives, this is about Girl Power! So, come on!' Their outfits captured the variables of '90s fashion in all its glory. Emma Bunton was Retro Spice, wearing a silver dress and signature go-go knee-highs. She looked like a sixties pin-up and grabbed the mike, giggling: 'Can you believe it, I almost slipped up again! I'm getting rid of these boots!' Mel B was Techno Spice, wearing a green bra top, matching shiny flares and sonic double hair cones bound in ribbons like Princess Leia. Sporty was Clubby Spice in a crop top, and Posh was very much Glamorous Spice in a minimalist gold tube dress. The girls were on top of the world. And that night, right there in Rotterdam, brimming with self-belief, they went and fired their manager, deciding it was time to take their careers

Don't be jelly, boys – the Spice Girls win the MTV EMA for Best Band ahead of a number of all-male acts, 1997.

entirely into their own hands. There was little to dispute their influence – they were just about to release their movie, a few days away from starring in celebratory TV show *An Audience With* in front of an all-woman audience that would go on to pick up over 12 million viewers, and on the cusp of a new round of promotional appearances to support their second album, which had been released earlier that month and would reach number one in 13 countries.

THIS PAGE: *The Spice Girls' MTV EMA performance in Rotterdam, November 1997.*
OPPOSITE: *Pride – the Spices celebrate their EMA for Best Band in 1997.*

Some Kind of Superstar

What to wear to meet a Nobel Peace Prize Winner, and South Africa's first Black president, whose 27 years in captivity as an apartheid activist helped destroy an irreconcilably oppressive regime? Posh wore a gold satin suit and a Wonderbra. Scary chose a double mock-croc ensemble – olive green trousers and a burgundy coat, contrasted with a leopard bra. Baby donned a ditsy-print slip dress and platforms, while Geri was a vintage lady in red – a qipao mini-dress and handbag. Sporty characteristically went casual in a baggy DKNY-logo t-shirt and sneakers. The girls were in town playing a gig in Johannesburg and were thrilled to go along to the photocall with Prince (now King) Charles, who was also on a visit. When one of the paps asked Mandela what he thought of the SGs, Scary was quick off the mark to head off any impish responses, turning to the President and saying: 'Watch it! You're stood next to me.' She needn't have worried. Like many others around the world, he found the girls totally irresistible.

The Spice Girls pose for pics with legendary South African leader Nelson Mandela and Prince Charles (now King Charles III).

' You know, these are my heroines...
this is one of the greatest days of my life. '
South African President Nelson Mandela, November 1997, Pretoria.

The Same but Different

The Spice Girls seemed to have conquered the entire planet when *Spice World* debuted in 1997. On 15 December that year, their first premiere took place at The Leicester Square Empire, and they busted out an unusually united sartorial front by wearing matching black pinstriped suits. Baby swaggered down the red carpet with a cane and Geri camped it up with a big fat cigar, turning the tropes of masculinity upside down and owning their big-screen moment by showing up as a regular gang of girl bosses. The film would take over £6 million during its UK opening weekend alone. After a whirlwind publicity campaign, the girls' final stop was at The Mann's Chinese Theatre in Hollywood where they arrived in an open-top Union Jack bus, this time sporting all-white suits, alongside Beefeaters (who would normally be guarding the Tower of London).

Historically, suits have often been provocative power-moves for women. In 1933, Marlene Dietrich reportedly wore an all-white suit on a trip to Paris and the police wanted to arrest her

THIS PAGE: *Women of the USA's Democratic Party unite at President Trump's state of the union address in 2019.*
OPPOSITE: My Strongest Suit – *together at the London premiere of* Spice World the Movie, *Leicester Square, December 1997.*

' The thing they did worked...
and it worked everywhere. That's all that really matters,
it's the pop thing... '
Bob Geldof, *Spice World the Movie* premiere, London, 1997.

for it, with 'masquerading as men' being considered a crime. The impact of a woman in a suit still resonates today across every different social stratum. For the Spice Girls, their white-suit wearing was a conspicuous display of girl power, and similarly, the House Democratic Women's Working Group (a campaign group within the USA government's House of Representatives) regularly calls on its members to co-ordinate and wear white suits, telling CNN in 2019: 'Wearing suffragette white is a respectful message of solidarity with women across the country, and a declaration that we will not go back on our hard-earned right'.

The white stuff – the Spices go to Hollywood, January 1998.

Look at Me

On 31 May 1998, Geri's solicitor announced she had left the Spice Girls. A little more than a year later, she released her debut album, *Schizophonic*, with its lead single 'Look at Me' going gold around the world. When Halliwell trod the red carpet at the January 2000 NRJ Music Awards in Cannes to promote her solo work, she chose an emerald-green tropical 'jungle print' silk chiffon dress by Versace, originally worn by Amber Valetta on Donatella's S/S 2000 catwalk and shot for their summer editorial campaign by Steven Meisel. It was a daring choice, with an ultra-low-cut neck that plunged to her navel, the floor-length skirt silhouette billowing out, showing every inch of leg. Donatella herself had worn a sleeveless version of the gown to the 1999 Met Gala, which celebrated the launch of its Rock Style exhibition.

Halliwell arrives at the 1st Annual NRJ Music Awards, January 2000.

But the dress wasn't done yet. At the 42nd Grammy Awards in February 2000, Jennifer Lopez, against the wishes of her stylist – who pointed out that a Spice Girl had already worn the piece so it might well be over-exposed – decided to don it while presenting the best R&B Album gong. As a result, the frock actually changed the way users explore the internet, as Eric Schmidt, a *Google* executive explained: 'At the time, it was the most popular search query we had ever seen. But we had no sure-fire way of getting users exactly what they wanted: J-Lo wearing that dress. *Google Image Search* was born.' Geri is famous for many things, but a footnote in her bio will always tell the world that she was the Spice Girl who wore the first internet-breaking outfit before J.Lo.

THIS PAGE: *Lo plunging – Jennifer Lopez at the Grammy Awards in February 2000.*
OPPOSITE: *Geri Cannes – Ginger returns to the French city to promote her solo work in January 2000.*

World of Sport

' I know what suits me: simplicity, tailoring, a more androgynous look. I've always liked that rock'n'roll chic. '

— Mel C, the *Guardian*, March 2020.

Melanie Chisolm's debut album, *Northern Star*, released in October 1999, sold over 2 million copies worldwide. It was an impressive start to an independent career beyond the Spices, and it wasn't just her musical direction that was recharged. Her wardrobe adapted to her new-found freedom too. In an August 2020 *GQ* interview, she explained: 'Once I went solo, and I was still only 25 at that point, I wanted to be seen as an individual and I did things in order to distance myself from the group, perhaps. I became a bit rebellious: I cut my hair, put out a single that was a bit rockier...' Experimenting with designers, she soon picked up on Alexander McQueen, admitting to the *Daily Mail* in March 2011: 'I'm a huge Alexander McQueen fan. I've got lots of the most beautifully cut jackets, some lovely boots, a gorgeous little clutch bag. I love McQueen's designs and McQ, the sister line — his designs are always wonderful and fun... The scarves are so cool. You can be wearing anything and then put on an Alexander McQueen scarf and it really makes the look.'

THIS PAGE TOP: *Mel C in an Alexander McQueen scarf at Heathrow Airport in 2007.*

THIS PAGE BOTTOM: *Yoko Ono in Tokyo, 2010.*

OPPOSITE: *C me now – Sporty Spice performing as a solo artist alongside Matt Cardle in August 2013.*

McQueen's iconic skull scarf originally appeared on his summer 2003 catwalk and went on to become one of the label's most iconic pieces. After the designers' death in 2010, it became a touchstone for devotees. His legacy was revived in 2013 with a 30-piece limited edition created in collaboration with artist Damian Hirst and inspired by the original skull scarf. Mel C has become an expert on the avant-garde original and in a 2016 interview with *Vogue*, she revealed that, of the many treasures of Sporty Spice's wardrobe, one of the pieces she's kept is an Alexander McQueen suit. She was also spotted at a 2013 G-A-Y performance in an orange body-con McQueen dress. She also has a penchant for wearing a certain someone else's designs, revealing to *refinery29.com* that 'Mrs. Beckham, of course' is also among her favourites: 'She's been so good to me. I've worn her dresses for awards, and I really love how her line has evolved; it's really casual yet chic, with beautiful, luxe robes and jumpers. *Gorgeous*.'

Mel C outside The Late Late Show *in Dublin, 2012.*

Friendship Never Ends

> '*Thank you to my beautiful friend @victoriabeckham for dressing me and my mum making us feel like queens.*'
> — Mel B, *Instagram*, May 2022.

Melanie Brown will always be famous for her love of animal print. She revealed to the *Sunday Times Style*'s 'Dopamine Dressers' feature that: 'Everything I own is leopard print. Mugs, eye masks, backpacks, clothes. It's me, and it's never gone out of fashion.' And looking back on her fashion choices over the years, she always thinks, 'I nailed it!' After the Spice Girls, numerous appearances on *X-Factor* and *America's Got Talent* saw Mel B stepping out in designer outfits by Valentino and Stella McCartney, paired with Louboutin shoes, while carrying any one of her four Hermes Birkin bags.

Mel B's love of upmarket labels hit the headlines during her 2017 divorce proceedings, when the LA judge broadcast to the world the contents of her closet, divulging a suitably A-list rollcall of it-bags, including an Yves Saint Laurent 'Muse and Downtown' tote, Louis Vuitton's 'Artsy Hobo', and a Chanel Cocoon. Mel has since leaned into her Scary past, telling *Heat* in 2019: 'When I stood onstage in my full Scary Spice outfit, a part of me felt like I was reclaiming who I was'.

Mane attraction – Scary Spice lights up the America's Got Talent Fantasy League *in LA, November 2023.*

In May 2022, when a visit to Buckingham Palace beckoned, she called on her old mate Vicky B for a dress from the chic and suitably posh VB brand. As Victoria explained via *Instagram*, Mel chose a 'T-shirt dress in Tomato Red, an iconic VB silhouette and colour', as well as 'a VB T-shirt dress with subtle off-white check motif' for her mother, Andrea, who accompanied Mel to the ceremony, where Mel received an MBE for her work as a Woman's Aid patron. The girls celebrated their friendship that evening over dinner, with Victoria saying Mel was a 'true role model' and that 'it was such an honour to dress you and your mum'. However, despite the elegant occasion, Mel couldn't help spicing things up with a sprinkling of her wild-child ways. Underneath the sleek and chic body-con dress, she reportedly went bra-less and when asked by Posh if she wanted nipple covers, she retorted, 'why bother?'

Mummy B with her daughter after Mel was awarded an MBE by Prince William, 4 May 2022.

Maybe Baby

' Oh yeah, that's how I've grown up.
I've become saucy. '
— Emma Bunton, the *Guardian*, November 2006.

Fashion and music have forever enjoyed a symbiotic relationship. There are times when a rock or pop star is seemingly set in amber and will always be seen in a certain way. Ronnie Spector's wing-tip eyeliner, Amy Winehouse's beehive, and Kate Bush's leotards are still remembered today as iconic sartorial calling cards. When you've grown up in the public eye as Baby Spice there is very little to be done to shake off how people see you. In 1997's *Spice World the Movie*, Emma Bunton, just 21 years old and all wide-eyed, declares: 'You know, I'm always gonna be known as Baby Spice, even when I'm... 30!' And arguably, she was right. Emma's wardrobe while she was in the band was unequivocal: bunches, short skirts, Buffalo boots and tiny T-shirts were her trademark. Decades later, these have become collectible '90s retro pieces – Baby Spice remains an indelible avatar. Grown adults are still possessed by nostalgic adoration for her. Blake Lively fangirled Bunton live on Jimmy Fallon's show in 2018 and when Baby left a message for the actress on *Insta*, Lively dissolved, saying: 'Forever bowing down to you. I cannot believe you know who I am. This will never be normal.'

THIS PAGE: *Sugar and spice – Baby onstage in 1997.*
OPPOSITE: *Baby face – Emma Bunton's effortlessly youthful looks, 1997.*

Leaving the Spices and breaking out on her own was a bit of a journey for Bunton. Her super-sexy side emerged at the 2000 VH1 Vogue Awards in Monaco. She bowled up to the party wearing a plunging, black diamanté, body-con dress, her hair super-straightened, looking fierce and totally on point – a million miles away from her pink, lolly-pop Spice Girl persona – accompanied by her ever-swanky compadre Victoria Beckham. The two giggled the night away on the red carpet, occasionally interviewing other celebs about their outfits, all in typically impish fashion. In one clip, they look directly into the camera and brazenly assert that future president Donald Trump, standing behind them, looks like a banker and as Victoria adds, 'Not at all stylish'. Two retro icons, streaks ahead of their time. And Bunton was very much Va Va Voom Spice that night, not a pigtail in sight.

THIS PAGE: EMA Bunton – Baby Spice onstage during a performance at the MTV EMAs in Stockholm, 2000.
OPPOSITE: Emma on the red carpet at the VH1/Vogue Fashion Awards, 20 October 2000.

She's in Fashion

Today, Posh Spice is often seen sashaying into the most exclusive fashion parties wearing pared-down, boyish silhouettes. She has even been spotted wearing flats. Of course, she still looks posh, but Victoria is very much an A-list style-maker. These days, the editor of American *Vogue*, Anna Wintour, wouldn't miss a VB catwalk for anything and is always sat front row. Since leaving the Spice Girls, Victoria has become the band member most connected with the fashion industry, and the DNA trail was always there to see – Posh famously favoured her little black Gucci dresses and walked Maria Grachvogel's catwalk during London Fashion Week February 2000. It felt a natural move when she co-authored a 2007 style bible, *That Extra Half an Inch*, saying at the time: 'I've always been a girls' girl. And I know from experience that making the very best of yourself is something any woman can do. I was never the six-foot-tall pin-up. I've always been the girl-next-door who got lucky.' The same year, Beckham appeared as herself in the American smash-hit style-magazine sitcom *Ugly Betty*, softening the cognoscenti by

THIS PAGE: *Victoria Beckham on the runway with designer Maria Grachvogel in 2000.*
OPPOSITE: *Wintour's night – Anna Wintour with Victoria at Bergdorf Goodman, September 2012.*

revealing just how good she was at self-depreciation and how refreshing a combination of style and wit can be. The following year, in 2008, Victoria launched her own label with a carefully curated collection of 10 dresses at New York Fashion Week. The industry insiders were quietly impressed.

The VB brand has evolved into a global name and today stands on its own strengths. It now has devotees who have no idea what Victoria did in the '90s. For them, Girl Power is how her fits make them feel. In 2017, the Queen awarded her an MBE for her services to fashion and in 2018, to celebrate 10 years of her label, Victoria looked to Juergen Teller to create a characteristically clever and joyful campaign. Teller was the same art photographer who had famously created a campaign for Marc Jacobs back in 2008, in which Beckham was captured sitting in a Marc Jacobs shopping bag, long legs akimbo and stretching out of it. VB's collaboration with Teller a decade later revisited the famous image, this time with a bag from the Victoria Beckham store. She said at the

'When Marc Jacobs featured me coming out of a shopping bag… it really was the **beginning of my journey into the fashion industry.** It was funny and ironic and brilliantly captured by Juergen Teller. And it came out just as I was **about to present my debut collection.**'

Victoria Beckham, *victoriabeckham.com*, 2018.

time: 'I have always put all of me into my brand, and I wanted to convey that message with these images.' VB today is a company that high-profile fashion and beauty stars clamour to collaborate with. In 2020, the Augustinus Bader X Victoria Beckham range of rejuvenating skincare was a savvy success. In 2022, VB worked with model and Gen-Z influencer Mia Regan on a forward-thinking capsule denim collection. It's a demonstration of Beckham's style sharpness and, as she told the *Guardian* in 2020: 'My confidence has definitely grown as I've got older. I know what works on me, what looks good, what makes me feel confident and comfortable. I don't feel I have anything to prove now in the way I dress.'

Queen Victoria – VB at the Victoria Beckham Womenswear S/S 2024 show in Paris, September 2023.

Secret's Out

' Girl Power is back and it's **stronger than ever!** '

The Spice Girls press conference, The Millennium Dome, June 2007.

When Geri left the Spice Girls in 1998, it was a difficult time for devotees, who had quickly come to rely on the SGs and the scaffold of Girl Power. Their followers had made connections that went beyond the usual parasocial one-sided fan experience. The girls had a community they cared about. So, the rest of the band continued as a dynamic fourpiece for a couple more years before, in December 2000, finally announcing it was time to pursue independent projects. Ever since then, fans have whooped with joy anytime there's even a whisper of a reunion. The Spices first teasingly reformed in November 2007, performing at the mega-wattage Victoria's Secret Fashion Show that took place in Los Angeles' Kodak Theatre. It was an energetic and welcome occasion – the girls saluted the audience before breaking into their opening track, 'Stop'. In an instant, everyone was enveloped again by Spice Girls' exuberance. It felt like they had never gone away. As usual, the gang dressed to have fun and signalled their union with tight choreography and with their wardrobes, wearing harmonizing retro '40s army girl fits refashioned in luxe khaki and cream silk. Afterwards, they made a quick change into a parade of grown-up evening gowns to sing their new track, 'Headlines (Friendship Never Ends)' the single released with their greatest hits album, which they would go on to promote during the subsequent reunion tour, which kicked off in Vancouver that December.

OPPOSITE: *The Spices onstage at the Kodak Theatre during their Victoria's Secret performance in 2007.*
OVERLEAF: *Headline act – the girls perform their reunion single 'Headlines (Friendship Never Ends)' at the Victoria's Secret Fashion Show.*

I'm Giving you Everything

The Spice Girls joined the FROW at Roberto Cavalli's Autumn 2008 menswear show in Milan and it was a typically glitzy Italian fashion moment. Geri explained his appeal, simply saying: 'his clothes make you feel sexy'. Halliwell, Mel B and Emma wore electric body-con and heels, while Victoria and Mel C chose tuxedos, each one of them looking every inch the grown-up glamazons they had become. Cavalli, known for his sumptuous silhouettes, sent a series of impeccably dashing male models down the catwalk, all wearing after-midnight-blue and black suiting, trimmed with satin, with elegantly co-ordinating shirts and ties. The impact was luxuriant and, in tribute to the girls, the cigar-chomping designer added a few womenswear pieces that felt very Spice-appropriate: a baby-pink silk gown with marabou feathered trim and leg-of-mutton sleeves; a fiercely Scary leopard-print overcoat; and a crinoline floor-length evening gown with bandeau top that looked like it would fit Posh perfectly.

OPPOSITE: *Roberto Cavalli backstage with the Spice Girls in February 2008.*

' When I met them, I immediately understood **the reason why the world went crazy** for their unique brand of "girl power" – they are an irresistible mix of energy, pure joy, humour and a spicy dash of glamour. I'm sure their strength will **take us by storm again.** '

Roberto Cavalli, *Vogue*, November 2007.

After the traditional bow at the end of the show, Signore Cavalli gathered the girls, who gave him congratulatory fashion kisses. It was a show of reciprocal respect, underlining the best-friend relationship he enjoyed with Victoria, who wore his clothes regularly. In fact, at Victoria's request, Cavalli had gladly created the Spice Girls' wardrobe for their reunion tour. Their 2007–8 getups were full of his trademark flamboyancy, with silver catsuits, leather mini-dresses and Swarovski-embellished evening gowns turbo-charging their onstage energy. In a November 2007 *Vogue* interview, Cavalli enthused: 'At their debut, the Spice Girls generated a trend with their individual looks and now, ten years later, they have put their trust in me to get a new, unique and iconic appeal for the tour.'

In season – the Spices go full-fashion for Roberto Cavalli's A/W 2008/2009 show in Milan, January 2008.

The Joy You Bring

On 12 August 2012, with their designer threads dazzling, the Spice Girls were delivered by black cabs into the maelstrom of the London Olympics closing ceremony. The escalation of excitement shook the stadium walls as they emerged. In front of an estimated global audience of some 900 million people, the girls sang their legendary anthems 'Wannabe' and 'Spice Up Your Life'. As the commentator told British TV watchers: 'it may have been a long time since they performed together but the Spice Girls sound like they haven't forgotten how to do it.' The blockbuster appearance was a high-octane blast of positivity that stirred up the crowd in the most fabulous way. The outfits drew on their '90s uniform, adapting their signature style-codes and evolving them into a contemporary version of their original girl power personas. Mel C donned a white catsuit by Bolton-based tailor Nafisa Tosh, along with silver wedge trainers by Italian designer Giuseppe Zanotti. Geri revisited her celebrated Union Jack dress, this time reimagined by Suzanne Neville, a British designer known for her elegant, corseted bridalwear.

Athleisure – the Spice Girls strut their stuff at the London Olympics closing ceremony, 12 August 2012.

' We did it!!
I love u girls so much!!!!! xxx vb '
Victoria Beckham, X, August 2012.

The legendary tea towel was transformed into a boned girdled mini dress, embellished with gold embroidery and just a tiny bustle of red, white and blue. Baby Spice wore pink of course but gave it some zig-a-zig ah with a strongly silhouetted dress designed by Maggie Cooke, featuring sparkling capped pagoda shoulder detailing. Mel B busted her signature catsuit, this time in all-gold and created by Lebanese designer Zuhair Murad, looking chic rather than scary. Victoria Beckham looked to her old pal, British designer Giles Deacon, to produce one of her signature little black dresses. The fashion darling produced a suitably posh frock with frills and a strapless bandeau top. Afterwards, Geri capped the special moment by tweeting: 'that was amazing!!!! Thank you all, we love you!!xx.'

Taxi for five – the Spices' Closing Ceremony performance at the London Olympics in 2012.

Viva Forever

'Viva Forever' started life as a song on the Spice Girls' second album, *Spiceworld*. It was the final single released from the album, coming out in July 1998 – after Geri's departure from the group. The lyrics sang of the end of a summer romance with nostalgic connotations that somehow captured the moment. While Posh, Sporty, Baby and Scary continued with a blockbuster world tour, it felt inevitable that the girls, even then, were beginning to think about spreading their own wings and moving on with their lives. The video, directed by Steve Box, depicted the band as animated fluttering fairies and he revealed in a 2017 *Crack* interview: 'It's like the sadness of the song is leaving your childhood behind. Pop music is all about sex and love, so becoming interested in that, you suddenly put the toys away, you start to grow up in a different way.'

Power of 5 – Victoria, Geri, Mel C, Emma and Mel B, all together at the peak of their dramatic rise, 1997.

'I'm still very close to all of those girls. I'm really proud of what I achieved with them. We were just five girls who weren't all that great individually, but together, we were pretty great!'

Victoria Beckham with Fern Mallis, 2015.

Fast-forward to November 2012 and Victoria, Emma, Mel C, Mel B and Geri came together again for the premiere of a West-End musical written by *Absolutely Fabulous* comedian Jennifer Saunders and based around their legendary back-catalogue of block-buster hits. Titled *Viva Forever*, the show opened to rapturous audiences. Their careers together have always been mission improbable, defying critics and rising to stratospheric heights that even they never believed they could reach. In November 2022, the girls celebrated 25 years of *Spiceworld* with a special anniversary re-release, including a remix of 'Viva Forever', brightly highlighting for all time their place in pop history.

Spice Viva – the Spice Girls with the cast of Viva Forever, *November 2012.*

Image Credits

COVER: MJ Kim/Spice Girls LLP/Getty Images Entertainment
p.2: Brittany Smith/Alamy Stock Photo
p.9: Tim Graham/Corbis Historical/Getty Images
p.10: Brittany Smith/Alamy Stock Photo
p.14 TOP: ilpo musto/Alamy Stock Photo
p.14 BOTTOM: Neil Munns/Alamy Stock Photo
p.15: Mirrorpix/Alamy Stock Photo
p.16 TOP: Mick Hutson/Redferns/Getty Images
p.16 BOTTOM: Mick Hutson/Redferns/Getty Images
p.17: Actionplus/Alamy Stock Photo
p.18 TOP: Album/Alamy Stock Photo
p.18 BOTTOM: Michel Arnaud/CORBIS//Getty Images
p.19: Chris Walter/WireImage/Getty Images
p.21: Mirrorpix/Alamy Stock Photo
p.22: Chris Pizzello/Alamy Stock Photo
p.23: Neil Munns/Alamy Stock Photo
p.25: JMEnternational/Redferns/Hulton Archive/Getty Images
p.27: Sipa US/Alamy Stock Photo
p.29: TBM/Alamy Stock Photo
p.30 TOP: GL/GC Images/Getty Images
p.30 BOTTOM: Victor VIRGILE/Gamma-Rapho/Getty Images
p.31: JMEnternational/Hulton Archive/Getty Images
p.32: Pascal Le Segretain/Getty Images
p.33: dpa/Alamy Stock Photo
p.34 TOP: Pierre Vauthey/Sygma/Getty Images
p.34 BOTTOM: THIERRY ORBAN/Sygma/Getty Images
p.35: ZUMA Press, Inc./Alamy Stock Photo
p.36 TOP: JMEnternational/Getty Images
p.37: PA Images/Alamy Stock Photo
p.38 TOP: Marc Piasecki/GC Images/Getty Images
p.38 BOTTOM: Bettman/Getty Images
p.39: PA Images/Alamy Stock Photo
p.41: Anthony Devlin/Getty Images
p.42: AA Film Archive/Alamy Stock Photo
p.43: bill belknap/Alamy Stock Photo
p.45: Pascal Le Segretain/Getty Images
p.47: Dave Hogan/Getty Images
p.49: Dave Hogan/Getty Images
p.50: Chronicle/Alamy Stock Photo
p.51: Dave Hogan/Mission Pictures/Getty Images
p.52: Antonio de Moraes Barros Filho/WireImage/Getty Images
p.53: ©Columbia Pictures/Courtesy Everett Collection/Alamy Stock Photo
p.54 TOP: PA Images/Alamy Stock Photo
p.54 BOTTOM: Sean Zanni/Patrick McMullan/Getty Images
p.55: PA Images/Alamy Stock Photo
p.56: Venturelli/WireImage/Getty Images
p.57: Featureflash Archive/Alamy Stock Photo
p.58: Fabio Diena/Alamy Stock Photo
p.59: Trinity Mirror/Mirrorpix/Alamy Stock Photo
p.60: PictureLux/Alamy Stock Photo
p.61: Tim Roney/Hulton Archive/Getty Images
p.62: Ronald Dumont/Hulton Archive/Getty Images
p.63: Ian West/Alamy Stock Photo
p.64 TOP: Onnie A Koski/Getty Images Entertainment
p.64 BOTTOM: Alamy 2A303K6 Collection Christophel/Alamy Stock Photo
p.65: jeremy sutton-hibbert/Alamy Stock Photo
p.67: Alamy HCY6K8 Everett Collection Inc./Alamy Stock Photo
p.68 TOP: Alamy PFKHJH Shiiko Alexander/Alamy Stock Photo
p.68 BOTTOM: Getty 1150527028 Kirstin Sinclair/Getty Images
p.69: Alamy 2JH2MM8 AJ Pics/Alamy Stock Photo
p.70: Victor VIRGILE/Gamma-Rapho/Getty Images
p.71: Raymond Hall/GC Images/Getty Images
p.72: AJ Pics/Spice Productions/Alamy Stock Photo
p.73: REUTERS/Sergio Perez/Bridgeman Images
p.74 TOP: Michael Ochs Archives/Getty Images
p.74 BOTTOM: Michael Putland/Hulton Archive/Getty Images
p.75: Alamy DPM1WC ZUMA Press, Inc./Alamy Stock Photo
p.76: Estrop/Getty Images Entertainment
p.77: David Parker/Alamy Stock Photo
p.78: Michael Arnaud/Corbis Entertainment/Getty Images
p.79: Mick Hutson/Redferns/Getty Images
p.80: Suzan Moore/Alamy Stock Photo
p.81: Fabio Diena/Alamy Stock Photo
p.82 TOP: Dave Benett/Hulton Archive/Getty Images
p.82 BOTTOM: Dave Benett/Hulton Archive/Getty Images
p.83: John Stanton/WireImage/Getty Images
p.84: David Parry/Alamy Stock Photo
p.85: CelebrityArchaeology.com/Alamy Stock Photo
p.86: Myung Jung Kim/Alamy Stock Photo
p.88: Kirstin Sinclair/Getty Images Entertainment
p.89: John Stanton/WireImage/Getty Images
p.90: John Stanton/WireImage/Getty Images
p.91: Tim Graham/Pool Photograph/Corbis/Getty Images
p.92: Dave Bennett/Hulton Archive/Getty Images
p.93: Dave Hogan/Hulton Archive/Getty Images
p.94: Mirrorpix/Alamy Stock Photo
p.95: CHESKIN/Alamy Stock Photo
p.96: Mick Hutson/Redferns/Getty Images
p.98: ARNAL/GARCIA/Gamma-Rapho/Getty Images
p.99: Dave Hogan/Hulton Archive/Getty Images
p.100 TOP: Toni Anne Barson/WireImage/Getty Images
p.100 BOTTOM: Mike Egerton/Alamy Stock Photo
p.101: Andrew Benge/Getty Images Entertainment
p.102 TOP: Image Press Agency/Alamy Stock Photo
p.102 BOTTOM: Marcus Ingram/Getty Images
p.103: David Corio/Redferns/Getty Images
p.105: Anwar Hussein/Alamy Stock Photo
p.106: Media Punch/Alamy Stock Photo
p.109: Fabio Diena/Alamy Stock Photo
p.110: Fabio Diena/Alamy Stock Photo
p.111: Fabio Diena/Alamy Stock Photo
p.113: Mirrorpix/Alamy Stock Photo
p.114: Olivier Douliery/ABACAPRESS/Alamy Stock Photo
p.115: Tim Graham/Sygma/Corbis/Getty Images
p.117: Vinnie Zuffante/Archive Photos/Getty Images
p.119: Toni Anne Barson Archive/WireImage/Getty Images
p.120: Scott Gries/ImageDirect/Hulton Archive/Getty Images
p.121: Alain BENAINOUS/Gamma-Rapho/Getty Images
p.122 TOP: Brian Rasic/Getty Images Entertainment
p.122 BOTTOM: Jun Sato/WireImage/Getty Images
p.123: WENN/Alamy Stock Photo
p.125: WENN/Alamy Stock Photo
p.127: AFF/Alamy Stock Photo
p.129: Dominic Lipinski/Alamy Stock Photo
p.130: JMEnternational/Redferns/Hulton Archive/Getty Images
p.131: John Stanton/WireImage/Getty Images
p.132: Dave Hogan/Hulton Archive/Getty Images
p.133: George De Sota/Newsmakers/Hulton Archive/Getty Images
p.134: REUTERS/Bridgeman Images
p.135: Jamie McCarthy/Getty Images Entertainment
p.139: Peter White/Getty Images Entertainment
p.141: Steve Granitz/WireImage/Getty Images
p.142-43: Jon Kopaloff/FilmMagic/Getty Images
p.145: MJ Kim/Spice Girls LLP/Getty Images
p.147: Venturelli/WireImage/Getty Images
p.149: Andrew Milligan/Alamy Stock Photo
p.151: David Davies/PA Wire/Alamy Stock Photo
p.153: John Stanton/WireImage/Getty Images
p.155: Photo by Dave M. Benett/Getty Images Entertainment

References

'Spice Girls: Too Hot to Handle' Chris Heath, *Rolling Stone*, 10 July 1997
bbc.co.uk/news/entertainment-arts-53600726
bbc.co.uk/news/entertainment-arts-66236843
billboard.com/culture/tv-film/emma-stone-spice-girls-namesake-fallon-video-8484159/
Brown, H. (1997) 'Hot in the city; Fashion', *Times*, 14 Jun 1997.
campaignlive.co.uk/article/pepsi-keep-spice-girls-98/63910
cbc.ca/arts/melanie-c-tells-us-what-we-want-what-we-really-really-want-to-know-in-her-candid-new-memoir-1.6654989#:~:text=But%20all%20we%20can%20do,%2C%20always%20a%20Spice%20Girl.%22
crackmagazine.net/article/long-reads/the-untold-story-of-the-lynchian-video-for-the-spice-girls-viva-forever/
dailymail.co.uk/tvshowbiz/article-10785375/Mel-B-parties-pal-Victoria-Beckham-amid-MBE-honour-shunning-advice-wear-nipple-covers.html
eonline.com/news/985806/victoria-beckham-reveals-how-the-spice-girls-influence-her-passion-for-fashion-at-the-pcas
footwearnews.com/fashion/celebrity-style/spiceworld-the-exhibition-celebrates-20th-anniversary-of-spice-girls-shoe-style-218638/
gq-magazine.co.uk/culture/article/melanie-c-interview-2020
graziadaily.co.uk/fashion/shopping/mel-b-style-transformation-went-scary-chic/
harpersbazaar.com/uk/culture/a28100322/geri-horner-spice-girls-virgin-interview/
harpersbazaar.com/uk/culture/culture-news/news/a41252/donald-trump-hitting-on-emma-bunton/
hellomagazine.com/healthandbeauty/mother-and-baby/20211019124293/emma-bunton-home-life-and-kids-interview/
HOLGATE, M., 2010. Coming Down. *Vogue*, 200 (3), pp. 364-n/a.
housebeautiful.com/design-inspiration/celebrity-homes/a36555801/yves-saint-laurent-color-archive/
huffpost.com/entry/sneaker-wedges_b_1541355
i-d.vice.com/en/article/y3dzyb/catsuits-fashion-trend-popstars-superheroes
ign.com/articles/2005/02/11/emma-bunton-interview
marieclaire.com/celebrity/a21505/geri-halliwell-spice-girls-story/
mirror.co.uk/3am/celebrity-news/inside-story-spice-girls-first-14115144
modaoperandi.com/editorial/designer-spotlight-victoria-beckham-interview
mtv.com/news/u88cky/spice-girls-girl-power-lyrics
musicweek.com/talent/read/from-the-archive-the-spice-girls-first-ever-interview/065364
naair.arizona.edu/hopi-tribe
nylon.com/fashion/spice-world-fashion-25-anniversary
scmp.com/magazines/style/celebrity/article/3153344/8-celebrities-who-were-inspired-spice-girls-why-adele
smh.com.au/entertainment/celebrity/melanie-c-on-raising-her-own-spice-girl-trump-and-why-she-no-longer-wears-adidas-20161212-gt900c.html
smh.com.au/entertainment/celebrity/melanie-c-on-raising-her-own-spice-girl-trump-and-why-she-no-longer-wears-adidas-20161212-gt900c.html
thebowesmuseum.org.uk/vivienne-westwood-shoes-an-exhibition-1973-2011-launch-party-friday-10th-june-2011/
theguardian.com/culture/2021/oct/17/alan-cumming-memoir-my-favourite-movie-i-always-say-spice-world
theguardian.com/lifeandstyle/2020/jun/13/victoria-beckham-i-guess-it-was-a-sign-of-insecurity-wearing-very-tight-clothes
theguardian.com/music/2006/nov/18/popandrock.spicegirls
thetimes.co.uk/static/leopard-print-mel-brown-spice-girls-marks-spencer/
vice.com/en/article/3k4dmn/uncovering-a-cultural-history-of-the-nameplate-necklace
vogue.co.uk/article/mel-c-sporty-spice-interview
vogue.fr/fashion/article/spice-girls-style-inspiration-trends
vulture.com/2021/08/whos-who-in-the-suicide-squad-a-character-guide.html
wmagazine.com/story/kim-kardashian-azzedine-alaia-leopard-jumpsuit-vintage
wwd.com/feature/the-spice-girls-favorite-nineties-sneaker-brand-readies-a-comeback-11055882/
youtu.be/jVtU1ksRfZE
youtube.com/watch?v=FXKs4od2IrE
youtube.com/watch?v=IjMl-_owmIg
youtube.com/watch?v=u7xaEZhmAMk&t=2s

Acknowledgements

Many thanks to Carrie Kania at C&W Agency as well as James Smith, Craig Holden, Corban Wilkin, Sophie Hartley, Stewart Norvill and all at ACC Art Books. Also, to Andrew, Freddie and William Newman, Mick Rooney, Gina Gibbons, Pippa Healy, Michael Costiff, Francine Bosco and Jo Unwin for their love and encouragement.

Biography

Terry Newman is a fashion historian who worked in the industry for over 15 years as a journalist and stylist and now writes about fashion, art and culture. Recent books include *Legendary Authors and the Clothes they Wore*, *Legendary Artists and the Clothes they Wore*, *Harry Styles and the Clothes He Wears* and *Rihanna and the Clothes She Wears*, *Billie Eilish and the Clothes She Wears*, *Taylor Swift and the Clothes She Wears*, and *Beyoncé and the Clothes She Wears*. During the 1990s, she was employed as Shopping Editor at *i-D* magazine, Associate Editor at *Self Service* magazine, and Consumer Editor at *Attitude* magazine, and as a TV presenter for Channel 4 fashion programmes. Her journalism has been published in the *Guardian*, *The Times* and *The Sunday Times*, *Viewpoint* and the *Big Issue*, amongst others and she has contributed to *i-D*'s *Fashion Now*, *Fashion Now 2* and *Soul i-D* books. Newman currently lectures at Regents University London. She lives in London with her husband and two sons.

'We feel it's about time that girls come first for a change!'

Geri Halliwell,
An Audience with the Spice Girls, 1997.

Cover: Becoming one – *The Return of the Spice Girls Tour* arrives at the O2 Arena in London, 18 December 2007.
Frontispiece: Girl Power – the Spice Girls at the beginning of their rise to the top, 1996.

© 2024 Terry Newman
World copyright reserved

ISBN: 978 1 78884 259 4

The right of Terry Newman to be identified as author of this work has been asserted by her in accordance with the Copyright, Designs and Patents Act 1988

All rights reserved. No part of this publication may be reproduced, stored in a retrieval system, or transmitted in any form or by any means electronic, mechanical, photocopying, recording or otherwise, without the prior permission of the publisher

A CIP catalogue record for this book is available from the British Library

The author and publisher gratefully acknowledge the permission granted to reproduce the copyright material in this book. Every effort has been made to trace copyright holders and to obtain their permission for the use of copyright material. The publisher apologises for any errors or omissions in the text and would be grateful if notified of any corrections that should be incorporated in future reprints or editions of this book.

Project Editor: Stewart Norvill
Designer: Craig Holden

MIX
Paper | Supporting responsible forestry
FSC® C104723
www.fsc.org

Printed in China
for ACC Art Books Ltd., Woodbridge, Suffolk, UK

www.accartbooks.com

ACC ART BOOKS